t

se

n

s u

of

ns

y

d

~~Error.~~

Error.
And its emotions.
On the brink of error is a condition of fear.
In the midst of error is a state of folly and defeat.
Realizing you've made an error brings shame and remorse
Or does it?

Anne Carson

All Me

sse

up

unpredictable graphics

Anna Gerber

Laurence King Publishing in association with
HARPER DESIGN INTERNATIONAL *an imprint of*
HarperCollins*Publishers*

Contents

(Ian Anderson, Stuart Bailey,

Paul Elliman,

April Greiman, Stefan Sagmeister)

ALL MESSED UP

We've all had our computers crash at that crucial moment. We've all spilled a cup of coffee over everything. We've all found something beautiful or intriguing by chance – a note, a bus ticket – and ended up using it in our work in some way or keeping it for inspiration. And we've all come up against printers getting it 'wrong'. No matter how hard we try to control the creative process, it is inevitable that we encounter an element of unpredictability – something unexpected.

In striving for perfection, we make mistakes. In aiming for flawless work, things go wrong or take a different turn. And sometimes these mistakes and accidents end up working to our advantage – to the work's advantage. To embrace this is to override long-prevailing preconceptions that enforce the 'badness' of mistakes and accidents. Setting a context of the creative process and rescuing the accident from the pre-programmed wailing sound of sirens, this book collects work informed by unexpected mistakes and happy accidents, projects made great by error, chance and the unpredictable, a mass of beautiful work born from the idea that 'failure' can also be something positive.

B3NEFIC3NT ERROR

Mistakes and accidents, contrary to popular belief, can be employed to both evolve and push a piece of work forwards. We can think of these ideas in terms of process or even invention; a mistake prompted the discovery of penicillin and played a catalytic role in the inventions of everyday things such as the tea bag, Velcro, the Post-it Note, the X-ray, Silly Putty, Scotchgard, Ivory soap and even the Slinky. We can also think of mistakes as a visual language: either work is made to look like it deliberately consists of mistakes and imperfections (i.e. intentionally 'messed up') or created in order to subvert or challenge a perfectionist status quo.

Despite the derogatory associations of the word 'accident', we live in a flawed world where things do go wrong, where things inevitably fail. We also live in a world where, in order for progress to occur, things *need* to go wrong. The world needs accidents.

These ideas were explored by French social theorist Paul Virilio in a 2003 exhibition at the Fondation Cartier pour l'art contemporain in Paris called 'Unknown Quantity'. This was Virilio's first attempt at actualizing his idea of the 'Museum of Accidents' (based on an essay he wrote in the 1970s of the same name). While the exhibition focused more on natural disasters (the 1906 San Francisco earthquake, Typhoon Nari which shook the East China Sea in 2001, the 1910 Seine floods in Paris) and man-made catastrophes (the 1986 Chernobyl nuclear plant explosion, the Kenyan train derailment in 1999, the TWA Boeing 747 plane crash in 1997) than it did on the role of the accident in a creative context (as this book aims to do), it did draw attention to the undeniably powerful place that the accident continues to hold in the world. ~~While the exhibition focused more on natural disasters (the 1906 San Francisco earthquake, typhoon Nari which shook the~~

In his essay, 'Museum of Accidents' (originally published in the journal *Public*), Virilio argues that the accident should stop being seen as something that is separate from the world and instead be accepted as a part of the world and hence on equal footing (albeit in polarity) with perfection. 'The beginning of wisdom,' he writes, 'would be, above all, an awareness of symmetry between substance and accident, instead of constantly dissimulating them.' Or, as Robin Kinross put it in his article 'The Uses of Failure', 'An interest in failure is no more than a necessary part of an interest in how the world is.'

Virilio cites examples of inventions (the ship, train, plane) to illustrate the importance of accidents in furthering technological development and progress. As he says, to

invent the ship was to also discover the shipwreck; to invent the train was to invent its derailment. 'Each period of technological development, with its instruments and machines, brings its share of specialized accidents, thus revealing *en negatif* the scope of scientific thought.'

———

In an attempt to offer a practical adjunct to his theories, Virilio calls for a 'room' to be created in public information that focuses on fallibility, a 'room' that in his original essay he calls the 'Museum of Accidents' and which he now refers to as the 'first Major Accident Museum'. He explains that, in order for progress to be understood as something beyond the linear and continuous, there has to be an awareness of what he calls 'beneficent error'. The purpose of Virilio's museum is to familiarize researchers, scientists and engineers with the unexpected – with error – so that they might better avoid the dangers of habit. As he puts it, habit is a 'deformity' stemming from a complacent belief that technology should be ultimately flawless. The same can also be said of the role of habit within the creative context. If considered within this context, Virilio's idea of a museum (turned realized exhibition) becomes a forum in which dysfunctional objects can be observed and celebrated, underscores the idea that accidents and mistakes are essentially positive and ultimately rails against blind kowtowing to methods of habit and thoughtless routine and warns that such complacency will render meaningless the notion of the accident as helpful, useful or positive.

The idea of seeing and reconsidering the accident as something positive, with a particular emphasis on the creative process, was also the ~~was also the~~ focus of a 1998 conference held in Rotterdam called 'The Art of the Accident'. Hosted by V2, a centre for art and technology, the conference brought together a global selection of designers, artists, computer programmers and academics to strip the term 'accident' of its negative connotations (also one of the goals of this book).

If the world is thought to be an imperfect

If the world is thought to be an imperfect place, a space littered with continuous accidents, we can also understand, in the words of Ed Van Megen, one of 'The Art of the Accident' conference contributors, that, 'The things we produce have a tendency to malfunction as much as they function … Yet malfunction and failure are not signs of improper production.' When talking about the Association for Strategic Accidents ξ (the ASA), an organization devoted to popularizing the idea of what he refers to as 'voluntary sought risk', Van Megen goes even further in saying that the accident 'reveals the true identity of an object', that we have to 'stop negating the concept of "the accident" and start dealing with it in a much more productive way'. In other words, when something malfunctions, it doesn't necessarily mean that something is working against it, but rather that something is working in tandem with it to maximize its unforeseen potential. And ultimately, the 'malfunction' ends up revealing the authenticity of the object by exposing the object for what it really is.

Van Megen and Virilio's thoughts and writings remind me of many of the ideas derived from Chaos Theory, a scientific term used widely since the 1970s, which in the crudest of terms is about accepting irregularities in science rather than dismissing them as useless. In a general sense, the ideas behind Chaos Theory are not that far removed from Virilio's determination to draw attention to the symmetry that exists between substance and accident, or Van Megen's conviction that the accident reveals an object's true identity.

In 'pre-Chaos Theory' science, irregularities were considered nuances: things that would 'get in the way' of experiments. Chaos Theory advocates an examination of these disruptions so that emerging patterns can be investigated. As James Gleick explains in his book, *Chaos*, classical science believed that the 'irregular side of nature, the discontinuous

and erratic side' were 'puzzles to science, or worse, monstrosities'. Chaos Theory, like ideas aired at 'The Art of the Accident' conference and in Virilio's 'Museum of Accidents', creates a space for irregularities to be accepted and integrated, where formerly they would have been considered disruptive or negative.

Taking cues Taking cues from these ideas, the concept of 'beneficent error', along with the idea of creating a space for irregularities, opens the door for the 'accident(al)' to be recontextualized within the creative process as a catalyst and vehicle that allows and encourages a new kind of progress.

designed to malfunction

We can think of visual accidents in several different ways. In his book, *In Defence of the Accidental*, philosopher Odo Marquard talks about how accidents make us human, and how, without them, we would lose our sense of freedom. In the same way, we can think of visuals that are irregular, dirty, imperfect, decaying, amateurish or polluted as ways to help us retain our 'human-ness'.

Self-proclaimed 'exit-level graphic designer' Edward Fella first started experimenting with imperfect typography when designing flyers for the Detroit Focus Gallery. The flyers were a forum for Fella to explore and revel in the beauty of irregular spacing, or what he himself has referred to as 'anti-mastery': a kind of 'anti-aesthetic' that challenges and subverts all the means and measures that lead to 'slick' design. In an interview with Jeff Keedy, Fella explains that this imperfection originates from the culture we live in, 'Especially in graphic design, we're surrounded by really slick design. In order to break out of that, you either have to become the most facile professional of them all or chip away at it somehow.'

Much of the work shown in this book aims to 'chip away' at 'really slick design' as a way to retain and celebrate humanness and all its associative, wonderful flaws. Some typographic examples of chipping away at slick type design in this book include Fabrizio Gilardino's MarcelDuchamp Dirty – a 'noisy' and 'polluted' version of Letter Gothic; Jonathan Barnbrook's False Idol – a take on the kind of 'bad' Letraset type found in 1970s' porn magazines; and Paul Elliman's Bits font (for Fuse) – based on a bag of junk that he used to carry around with him. Each of these typefaces, complete with irregularities or (remembering Chaos Theory) 'nuances', succeed in 'chipping away at' or ~~on~~ subverting 'perfect' type design.

But before we accept completely that the imperfect aims (and, in some cases, succeeds) to subvert a certain status quo, we should also ask ourselves what it is about a dirty-looking typeface that we find so aesthetically and conceptually appealing. Is it because there's something uniquely human about it? Designer Barry Deck once said that its appeal lies in the fact that it is a 'type that reflects more truly the imperfect language of an imperfect world inhabited by imperfect beings'.

Another way to think about intended error (or what I've been referring to as 'the visual language of mistakes') is to look at technology specifically designed to malfunction. Two examples come to mind. The website for 'The Art of the Accident' conference, Deaf98, was programmed so that the more the user navigated through the site, the more ~~uner~~ unreliable it became, and ultimately the more it started to 'break down'. Netherlands-based design firm JODI has done similar work, most notably when it designed a collection of 'wrong' browsers, each with a difficult-to-use, almost impenetrable interface. Likewise, the website that Hi-Res! designed for Darren Aronofsky's movie, *Requiem for a Dream*, 'falls apart' the more the user navigates the site, giving the impression that it is crashing your computer.

Although one could argue that these examples of malfunctioning technology are the result of hours of painstaking computer programming, they actually offer us an example of not only how intentional mistakes can work, but also how they can lead to ground-breaking, excellent work. A question arises here. Is a planned accident still an accident? Are these programmes 'disqualified' because they're code-perfect? Does the 'dirty typeface' count any less because it has been designed to look that way?

The polluted typefaces, Fella's 'anti-mastery' and the malfunctioning technology all end up celebrating the wonders of human error. And in doing so, the 'mistakes' become inseparable from the work, a notion that harks back both to Virilio's ideas and to Chaos Theory, in so far as the manufactured or intentional nuances become the work itself. Taking this one step further, just as the work discussed couldn't exist without mistakes, nor could we – for mistakes are integral to what it is that makes us human. Or, in Marquard's words, 'To get rid of what is accidental would … mean … to rid man of all his too-humanness.'

SOMETHING BEYOND

ONESELF

Understanding the importance of the accident, its often positive role in the creative process, and the concept of making mistakes 'on purpose', we can now turn to the idea of systems as a way or device with which to encourage the unexpected: a system of rules that can be used (and created) to invite accidents into the creative process. Within this context, the system serves as a portal or vessel that encourages both the unpredictable and the accidental. Of course, the idea of creating and using systems to incite the unexpected, of looking to an external *agent provocateur* ('something' beyond oneself) for inspiration is nothing new. ~~In 1919, André Breton and~~

~~Philippe Soupault filled entire notebooks with spontaneous, 'automatic' sentences and~~

In 1919, André Breton and Philippe Soupault filled entire notebooks with spontaneous, 'automatic' sentences and published them as *Magnetic Fields*, now considered to be the first Surrealist novel. Breton explained that automatic writing consists of 'more or less incomplete sentences which at the onset of sleep, when one is quite alone, the mind is able to perceive'. This method of writing transported the Freudian notion of the power of the unconscious to the creative domain, enabling and allowing the unconscious to function as a creative tool.

Through automatic writing, the Surrealists recognized the importance of liberating themselves from 'reason' and opening themselves up to something beyond the self. As Michael Richardson writes in *The Dedalus Book of Surrealism*, the most significant part of automatism is that it revealed a different relationship between the artist and the creative act: 'Where the artist has ~~traditt~~ traditionally been seen as someone ~~who~~ invents a personal world, bringing into something with his own "genius", the Surrealists conceived themselves as explorers and researchers rather than "artists" in the traditional sense, and it was discovery rather than invention that became crucial for them.'

In a similar vein, the Surrealists invented a game called 'Exquisite Corpses' which invited the unpredictable to co-create. The rules of the game were simple. A piece of paper was folded into sections. The first player drew something on a fold, then passed it to the next player who, oblivious to what the previous player had drawn, drew something on his or her fold. When each member of the group of players had drawn his or her contribution, the paper was unfolded to its original size and then the collaborative, disparate doodles, drawings and writings, formed a unified piece of work. Exquisite Corpses is based on a system, a set of rules to encourage a piece

of work that none of the participants could have foreseen. With this example we see the importance of collaborations. Much of the work shown in the 'systems' section of this book stems from a collaborative approach, the methodology often involving the same kind of blindfolded technique that the Surrealists used when playing Exquisite Corpses.

It was Tristan Tzara, one of the founders of the Dada movement, who invented the Dadaist poem. In one of the Dada manifestos written in 1918, he explains 'How To Make a Dadaist Poem': 'Take a newspaper. Take some scissors. Choose from this paper an article of the length you want to make your poem. Cut out the article. Next, carefully cut out each of the words that makes up this article and put them all in a bag. Shake gently. Next, take out each cutting, one after the other. Copy conscientiously in the order in which they left the bag. The poem will resemble you. And there you are: an infinitely original author of charming sensibility, even though unappreciated by the vulgar herd.' Thirty years later, this set of rules was reappropriated and renamed 'the cut-up' by William S. Burroughs and Brion Gysin. With 'the cut-up', as with Exquisite Corpses and the Dada poem, we can start to think of these invented systems as something which encourages a kind of 'self-less' creative process, leading to the question: where is the poet (as we understand the idea of 'the poet') when creating/writing the Dada poem?

To conceive 'the cut-up', painter and writer Brion Gysin cut newspaper articles into sections, put them together at random, and published them as the book *Minutes to Go* (1959). His peer, American writer William S. Burroughs, took this even further when he wrote his novel, *Naked Lunch*, at random, sending a motley assortment of pages to the printer instructing that they be printed in no specific order. As Burroughs explained, 'You cannot will spontaneity. But you can introduce the unpredictable spontaneous factor with a pair of scissors.'

Staying with the concept of self-less systems, let's turn to New York artist William Anastasi, who created a series of 'blind' drawings (literally drawings Anastasi did with his eyes closed) called 'Constellations' in the 1960s. Later, he refined his technique and made another series of blind drawings while travelling to and from visits with John Cage. Aside from drawing with his eyes closed, he imposed a time limit on these drawings: the duration of the subway ride from his home to the home of John Cage. When talking about his blind drawings, Anastasi explained that he wanted to forget both art – its teachings, constraints, limitations, formulas, methods – and ultimately himself in order to embrace ego-lessness in his creative process.

The idea of taking oneself out of the creative process is best exemplified by John Cage's various forays into the subject. It was Cage who coined the terms 'chance operations' and 'indeterminacy' after using such disparate co-creators as the I Ching (*The Chinese Book of Changes*) and radio signals as *provocateurs* which enhanced the composition and creation of music. When talking about how he used the I Ching as a composition tool in an interview with Richard Kostelanetz, Cage explained, 'This is what you do if you are going to write by means of chance operations. You have to envisage exactly what are the questions you ask when you write music, then toss coins to help you answer these questions.' Later, Cage turned to different radio signals with the 'Imaginary Landscapes', where he arranged twelve radios on the concert stage, each stationed with two 'performers'. The score called for one 'performer' to adjust the station dial and the other 'performer' to regulate the dynamics. The unpredictable nature of the composition was based on the different and unknown radio frequency bands in different cities. In each of these examples, the idea of removing the 'self' from the creative process is very powerful; Cage assigns the role of answering questions to something outside of, or something other than, himself.

Also working with chance operations, avant-garde composer (and Cage peer) La Monte Young edited a book called *An Anthology of Chance Operations*, designed by the leader of the Fluxus art group, George Maciunas, in 1963. The book, a seminal Fluxus document, is a compendium of different propositions for chance operations created by musicians, performance artists, composers and artists. One of my favourite entries is La Monte Young's 'Composition 1960, Number 3', which reads, 'Announce to the audience when the piece will begin and end if there is a limit on duration. It may be of any duration. Then announce that everyone may do whatever he wishes for the duration of the operation.'

Cage described the idea of indeterminacy as something which is a 'truly experimental state of mind and action' that 'produces events the outcome of which cannot be foreseen'. not be foreseen'. He explains that his aim was to rid himself of the 'dictatorship' of the composer's role in order to move towards a self-less creation. In turning to either tossing coins or relying on unpredictable radio signals, Cage was attempting to strip himself of his own internal 'dictatorship' or else harking back to Anastasi as a way for Cage to forget 'himself'. ~~In the late 1970s Brian Eno and painter Peter Schmidt, heavily influenced by Cage's chance theories, conceived a deck of cards which they named Oblique Strategies. Each card had a cryptic suggestion printed on it like, 'Honour thy error as hidden intention' or 'Put it where it will be found.' Most famously used~~

In the late 1970s, Brian Eno and painter Peter Schmidt, heavily influenced by Cage's chance theories, conceived a deck of cards which they named 'Oblique Strategies'. Each card had a cryptic suggestion printed on it such as, 'Honour thy error as hidden intention' or 'Put it where it will be found'. Most famously used when producing the Talking Heads' albums *More Songs About Buildings and Food* and *Fear of Music*, Eno used the cards to catapult the band out of creative lulls when studio sessions

hit a low. 'It's a tactic', he has since mused, 'to keep you from falling into a rut.' ~~A more contemporary furthering of Cage's ideas can be found in the recent work by The Flaming Lips, the underground rock outfit from Oklahoma who cite Cage as a major inspiration. In 1997, The Flaming Lips first started staging the Human Boom-Box Experiment (their version of Imaginary Landscapes). On stage, they had forty boom-boxes (each controlled by one player, each~~

A more contemporary furthering of Cage's ideas can be found in the recent work by The Flaming Lips, the underground rock outfit from Oklahoma who cite Cage as a major inspiration. In 1997, The Flaming Lips first started staging the 'Human Boom-Box Experiment' (their version of 'Imaginary Landscapes'). On stage, they had forty boom-boxes (each controlled by one player, each given a bag of eight pre-recorded cassettes) arranged as two separate adjacent 'orchestras'. And under the direction of the band, different groups of boom-boxes playing different tapes were coordinated and synchronized into complete, yet completely unpredictable 'symphonies'. As Wayne Coyne, the band's 'composer' said of the experiments, 'You can hint at this collision of sounds and the unpredictableness of having these big compositions playing off each other, but to know exactly what's going to happen … it would be kind of like thinking you could write a novel and know every word before you start. You just don't.'

As N. Katherine Hayles writes in *The Art of The Accident*, 'The problem with plans of any kind, of course, is that they are limited by our intentions. And our intentions are limited by what we (already) know. How to intentionally escape intention, without having our escape plans contaminated by precisely that which we are trying to elude? Which is to say, how to open ourselves to what we cannot imagine?' In short, how do we get out of our own way?

Returning to the previous examples, La Monte Young's composition reads more like a series of instructions; where is he as composer? What about Tristan Tzara's poetry or Burroughs's writing: Where is the poet? The author? Cage took himself (his ego) out of the composer's role and relinquished his decision-making to the I Ching. Or, looking at this from another angle, La Monte Young surrendered his ego (as composer) to what the audience decided to do, Tzara (like Burroughs) surrendered himself as author to the chance arrangement of the text, Cage to the twelve radio dials. When thinking of systems like Cage's use of the I Ching or Eno/Schmidt's 'Oblique Strategies', we think of creating structures, games or systems that we can step away from – step outside of. The resignation of the self allows the system to determine the rest: to make decisions. This is how we get out of our own way. Our intention is to create something that is beyond our control.

UNPREDIC&TABLE GRAPHICS

Remembering what Virilio said, it is important to create a space where accidents, nuances, disruptions, irregularities, the imperfect and the unexpected can all coexist. This space, be it Virilio's museum or this book for that matter, exists in order to remind us that there is such a thing as beneficent error, that not all error is bad, that not all failure is to be avoided, that not all that is unplanned or unexpected need be an obstacle, and that, if we recognize these subtleties, we can encourage the unpredictable to take centre-stage in the creative process.

Considering these ideas in a visual way, work by designers like Ed Fella uses the irregular and the imperfect 'on purpose' as an aesthetic choice, a choice that serves as a challenge to the slick status quo. Likewise, with online projects designed to purposefully fail, like the Deaf98 website, the work is both a subversive antidote to, and commentary on, what can

feel like the suffocating standardization of technology. The accident also works on a conceptual level best exemplified by those who create and use systems to encourage that which cannot be foreseen.

The work in this book is divided into three different sections; each addresses a different 'type' of accident. The first section, 'mistakes', features work where either something has gone wrong (i.e. a printing error) or the work uses a strong mistake-laden visual language. The next section, 'chance', shows work where something has happened by accident or where something unexpected has happened (i.e. using a found object as the basis for a piece). And the final section, 'systems', features work that uses systems or rules to encourage the unpredictable in the creative process. As many of the ideas in these three categories overlap, I prefer to think of these categories as fluid signposts rather than anything definitive or rigid.

Ultimately, these ideas (and invariably the work in this book) are about opening ourselves up to what is unsafe, uncertain, unstable and uncomfortable and also about accepting these unpredictable states as something other than obstacles, in order to instead look at them as states of mind that enable the creative process to breathe, evolve and, ultimately, progress.

Anna Gerber, London, Anna 2003.

mistakes mistakes mistakes mistakes mistakes mistakes mistakes

CONTENTS

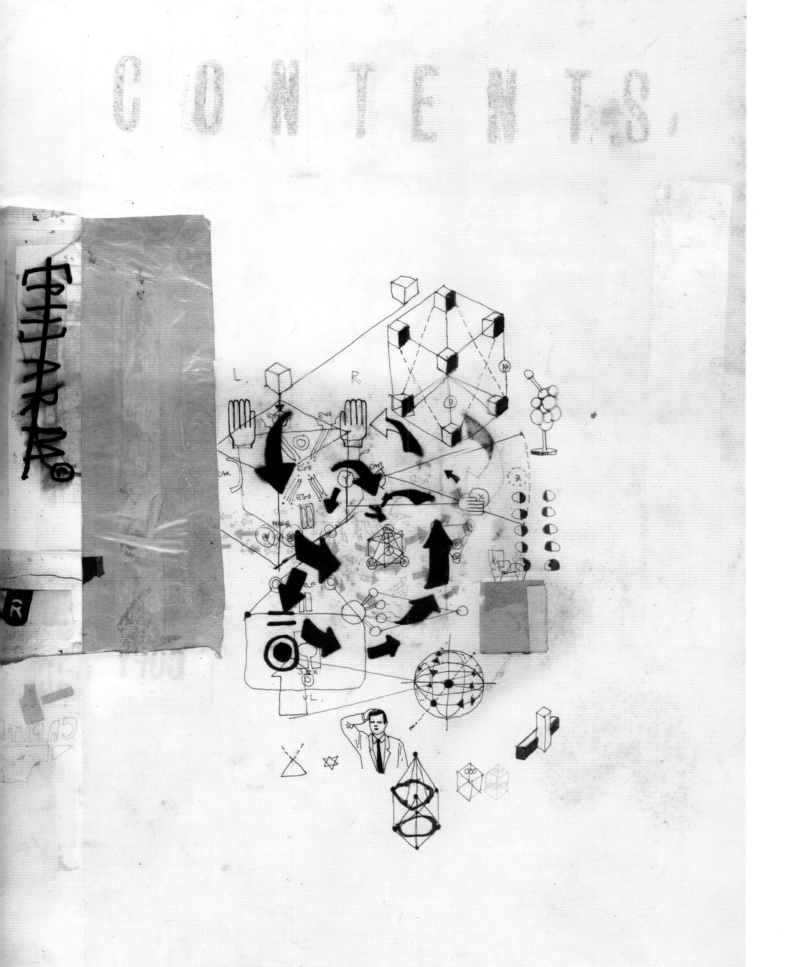

Neasden Control Centre,
***{PH}arm* book, 1998**

This self-initiated project – see also previous pages – is a one-off edition book, whose powerful visual language is rife with beautiful mistakes and stunning irregularities, and consists of found materials and objects, stains, torn pages, ink spillages, stickers, bits of packages. 'Pages were initially stained with oil,' say Neasden Control Centre, 'to produce layering effects but which later showed up earlier mistakes and typographic placement errors. Pages were ripped or torn accidentally during design, thus revealing several pages at a time; drawings erased with paint later formed background surfaces.'

number seventeen/
The Institute of Failure is a think tank set up to
study failure and its effects on all aspects of hu-
man endeavours. The Institute categorises failure
as follows: accident, mistake, weakness, inability,
incorrect method, uselessness. See www. institute-
of-failure.com for more information.

The last periods of some books (magnified 4266%)

Design and Form, Johannes Itten
Van Nostrand Reinhold,
1975, 3rd printing

Lolita, Vladimir Nabokov
Penguin Books,
1995, 3rd printing

Chairman, Tibor Kalman
Lars Müller,
1997, 1st printing

A Drinking Life, Pete Hamill
Little Brown and Company,
1994, 1st printing

Public Opinion, Walter Lippman
Free Press,
1997, 3rd printing

**The Museum As Muse,
Kynaston McShine**
The Museum of Modern Art,
1999, 1st printing

**A Field Guide to the Birds,
Roger Tory Peterson**
Houghton Mifflin Company,
1934, 43rd printing

A Designer's Art, Paul Rand
Yale University Press,
1985, 3rd printing

The Magic Christian, Terry Southern
Random House,
1959, 1st printing

**Artifice, Ruse and Subterfuge
At the Card Table, S.W. Erdnase**
Published by the author,
1908

**The Beauty Supply District,
Ben Katchor**
Pantheon Books,
2000, 1st printing

**The Odd Book of Data,
R. Houwink**
Elsevier Publishing Company,
1965, 1st printing

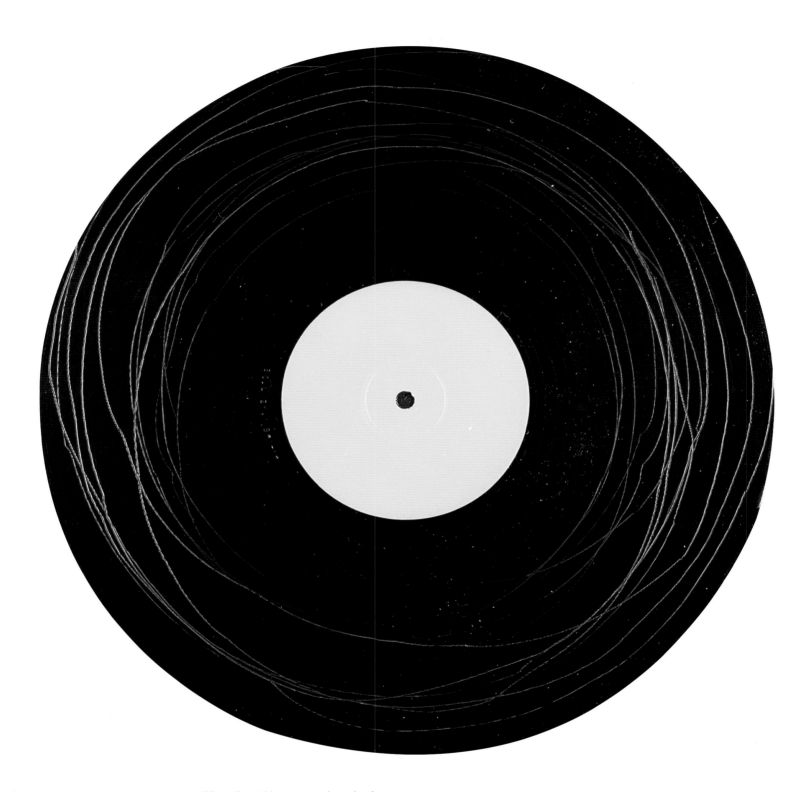

Peter Buchanan-Smith,
***The Last Periods of Sentences,* 2002**
For this special commission (which
incidentally resembles a periodic table)
Buchanan-Smith took his favourite
books and magnified the last period
at the end of the last sentence of each
book. 'There's a perceived "perfection"
to the last period', says Buchanan-
Smith, but when blown up, 'the period
becomes an interesting object, full of
flaws'. What appears to be a 'perfect'
circle, metamorphoses into something
altogether different, an opportunity to
put the beauty of imperfection under
the microscope.

When dispatching a new release by the
independent label, Soul Static Sound,
to retail chains HMV and Virgin, Wright
and Wilkinson ran into some problems
because they had hand-scratched the
vinyl. Upon unpacking their orders,
the retailers assumed the records were
faulty and returned the orders claiming
they were 'damaged' and 'destroyed'.
Similar problems met *From Here
To Eternity*, a solo release by Sonic
Youth's Lee Ranaldo, which featured a
locked groove at the end of every track.
This page
Ian Wright and Bob Wilkinson,
Scratched Records, 1997

Jake Tilson, Atlas,
Haworth Tompkins business cards, 2002
For these business cards,commissioned
by the architectural firm Haworth
Tompkins, Jake Tilson spent a day at
a printers experimenting with different
printing processes. Tilson played
around with under-inking and over-
inking sheets, varying the blanket
pressures and turning different ink
units on and off on a variety of
different stocks, to create a space
which 'allowed mistakes to happen'.

number 18.
The invention
came about by
1970, Spenc
ing on develor
in the 3M rese
From Instead, he de
ibly weak one.
scientist, Ar
Silver's weak
To markers in pl
In 1980, 3M s
Post-It Notes

Order

Please Supply:

Quantity	Unit	

marcel
duchamp
dirty

10

st-it notes
accident.
lver was work-
a strong adhesive
laboratories.
ped an incred-
1974, another 3M
Try, used some of
sive to keep his
n his hymn book.
d distributing
on-wide.

Description

**Fabrizio Gilardino, 2Rebels Type
Foundry, MarcelDuchamp Dirty
Typeface, 2001**
Fabrizio Gilardino, of the Montreal
foundry 2Rebels, designed this
typeface by rubbing Letter Gothic
characters with sandpaper, physically
cutting and pasting them, scanning
and altering them. The typeface, a
'noisy and polluted' version of Letter
Gothic, is defined by its irregularities
and disruptions.

Andy Warhol
Richard Branson
Vivian Westwood
Michael Angelo
Jenny Holzer
Gillian Wearing
Lawrence Weiner
Awften Senner
Michael Schumacher
Bruce Nauman
Ed Ruscha
Allen Wexler
Paul Elliman
Kurt Cobain

John Lennon
Yoko Ono
Picasso
Kristian Hersh
Mick Jagger
Dave Eggers
David Bowie
Bob Dylan
Mike Tyson
William Burrows
Allan Ginesburg
Jack Kerrack
Leonardo da Vinci
George Macunous

Che Chevagra
Damien Hurst
Tracy Emin
Martin Creed
Fichili & Weiss
Gerheed Richeter
Donald Judd
On Kawaslar
Jimi Hendrix
Marrion Faithful
Roger Daltory
Pete Townsend
Burny Ecolston
Ian Banks

Robert De Nero
John Loutner
Henry Ford
Ian maclaren
Madona
Debbie Harry
Thurston Moore
Kim Gordon
Kim Deal
PJ Harvey
Julliet Lewis
Adrian Newey
Aldus Hoxley
Bill Gates

Bob Geldof
Gandy
Mother Teresa
Maralyn Monroe
Charles Ray
Walt Disney
Georgio Armani
John Smeadly
Paul Smith
Billy Connoly
Mason Jennings
Luck Armstrong
Michael Jordan
Bruce Connor

Steve Maqueen
Tiger Woods
Merce Cunningham
John Cage
Bridget Bardo
Stan Brackbage
Neil Young
Eddi veader
Bill T Jones
Meredith Monk
Cindy Sherman
Jurgen Teller
Björk
Damon Alborn

Bruce Lee
Ernist Shackleton
Neil Armstrong
Lou Reed
John Cale
Nico
Jaspar John
Sid Vicious
Johny Rotton
Karl Sockhausen
Jan Tishold
Eric Gill
Adrian Frutiger
Felix Gonzales Torres

Nick Mason
Keith Moon
Keith Richards
Martin Brendel
Murry Walker
Brian Eno
James Dyson
Dolly Parton
Charles Satchi
George Orwell
Paul Newman
Frank Williams
Janice Joplin
Barry Shean

Henry Rollins
Nicholson Baker
Martin Amis
Alistar Little
Houdeni
Peire Manzoni
Man Ray
Marcel Duchamp
Michael Cane
Philip Glass
Robin Williams
Joan Biayers
Joseph Beuys
Rye Cooder

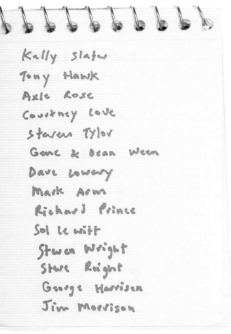

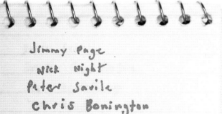

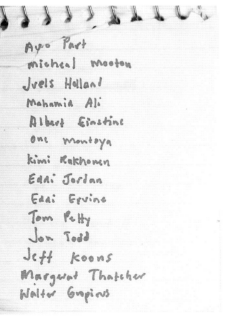

5. IN THELATE 1980S INASERIES OF PRINT S KNOW N AS ERE THERE IS TWHERE TH RE JOH CAGE EXXPERIMENTED WITH BRRANDING OON SMOKED PAPERHE FOUND CHARRRED PIECES OF CDISCARDED PAPER AND USIN A HOT PIECE OF IRON AT A CHANCE-DETERMINED POI T BASEDON RAN OM NUMBERS HE WOULD RRAND THE PAPER WITH A CI CLE OR A LINE O OR A IN SOME CASES BOTH.

Daniel Eatock, Foundation 33,
All the People Who Inspired Me, 2001
On 20th December 2001, Daniel Eatock spent an entire day in São Paulo, Brazil, making a list of everyone who had ever influenced him. 'I wrote down names of all the people I could remember that had positively influenced me through their work or actions, that I did not personally know. The names are written from memory and spelled from memory; many of the names are incorrectly spelled.' Of the 182 names, which span numerous pages of notebook paper, Eatock says, 'I imagined when writing that I would alphabetize and correct the spelling but now I feel the piece is all about the capturing of that one day and the randomness that came with the act of memory.'

KEEP THE IRREGULARITIES INCONSISTENT, VARIOUSLY DIFFERENTIATED, AND ★ OTHERWISE UNMATCHED IN ALL MANNER OF WAYS AND VARIETY OF SORTS.

'DEED I DO.

SO, SO.

ESIGNED FORCAMEBY : the ABOVE

Design Department
CRANBROOK ACADEMY of ART (and DESIGN)
P.O. Box 801
Bloomfield Hills MICHIGAN 48303-0801

NON-PROFIT
ORGANIZATION
U.S. Postage
PAID
PERMIT No 5
Bloomfield Hills MI

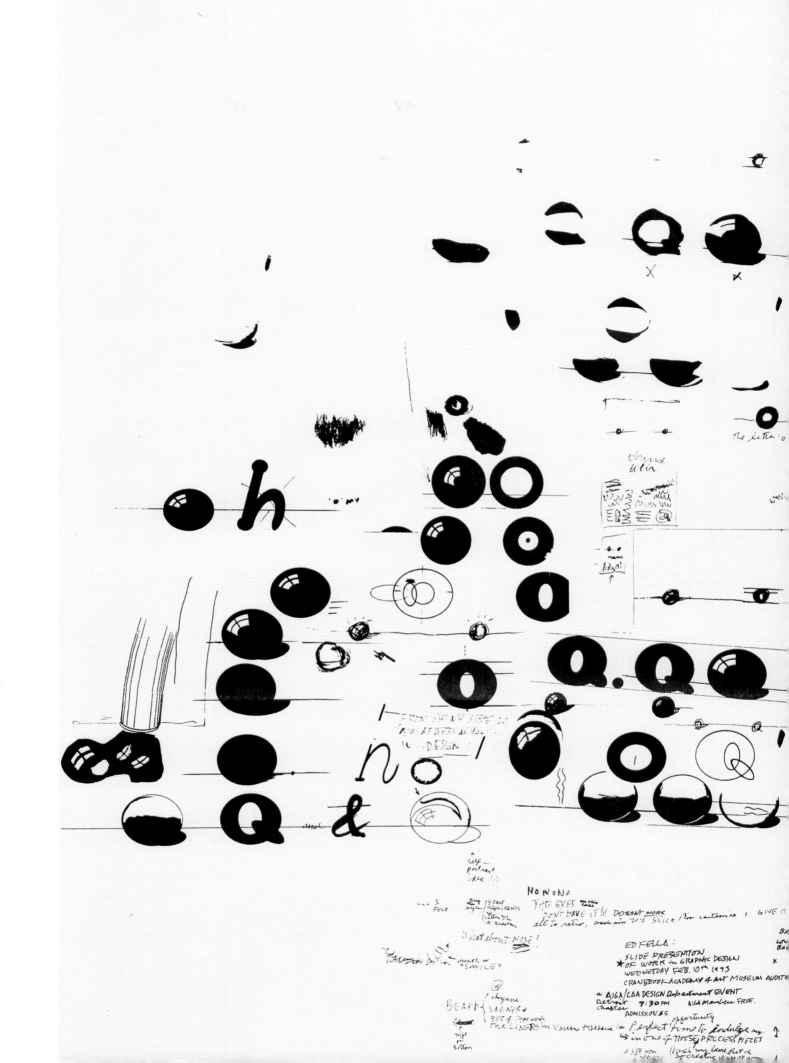

Previous pages
Edward Fella, *Keep the Irregularities Inconsistent* (front and back), 1993
The flyer shown is one of the legendary 'After The Event' anti-flyers that Fella posts around the California Institute of the Arts campus and sends out to people after an event has already taken place. The flyer, which features a hand-drawn typeface that Fella conceived at Cranbrook Academy of Art, exemplifies his fondness for using irregular spacing as a critique of commercial art. On the rear of the flyer, there is an 'unfinished attempt at drawing a man' as well as notes and doodles which 'show the process' of the work. As Fella puts it, 'All of my work now is done in a completely unpredictable and spontaneous manner, with the carefully constructed use of accidents and mistakes. There is something charming about doing things the wrong way.'

This page
Henrik Kubel, A2-GRAPHICS/ SW/HK, Paul Rand poster, 1999
When Henrik Kubel was asked to design a poster announcing a lecture by Adbusters at the Royal College of Art in London, he accidentally misspelled Paul Rand's name. As an apology for this mistake, he designed the poster shown here, which not only includes the original mistake but makes it an integral part of the poster's (re)design.

Opposite page
Henrik Kubel, A2-GRAPHICS/ SW/HK, *How many letters…*, 1998
How many letters… is a study of communication and language, an experiment with boundaries. The poster asks the question, 'How many letters can you take out of a sentence before it's unreadable?', its message ultimately being: at what point does language become completely illegible?

I AM REALLY SORRY PAUL! I WILL NEVER MAKE THAT MISTAKE AGAIN

This is an apology to Paul Rand, I spelled his name wrong on a poster announcing a lecture with Adbusters March 2nd 1999 at the Royal College of Art. Henrik Kubel Graphic Department. The Typography Workshop, March 99

Hw mny ltrs cn U tke out of a SnTNce B fR !"TS uN R DbLE?

Henrik Kubel first year graphics. Royal College of Art 1998. Typography Workshop. Tutor: Alan Kitching, Assistant: Darren Hughes. Typefaces: Grot 7 192 Points, Grot 9 192 Points, Baskerville Italic 18 Points.

14. THE FOLLOWING ERRATUM
APPEARED ON THE DAMNED'S
DEBUT ALBUM COVER IN 1977
(DAMNED DAMNED DAMNED):
"DUE TO RECORD COMPANY ERROR,
A PICTURE OF ISLAND RECORD-
ING ARTISTS EDDIE AND THE
HOT RODS HAS BEEN PRINTED
INSTEAD OF THE DAMNED. WE
APOLOGISE FOR ANY INCONVIENCE
CAUSED AND THE CORRECT PICTURE
WILL BE SUBSTITUTED IN
FUTURE COPIES. THE ALBUM
WAS REREJEASED IN 2002,
WITH THE ORIGNAL EDIE &
THE HOT RODS SLEEV3.

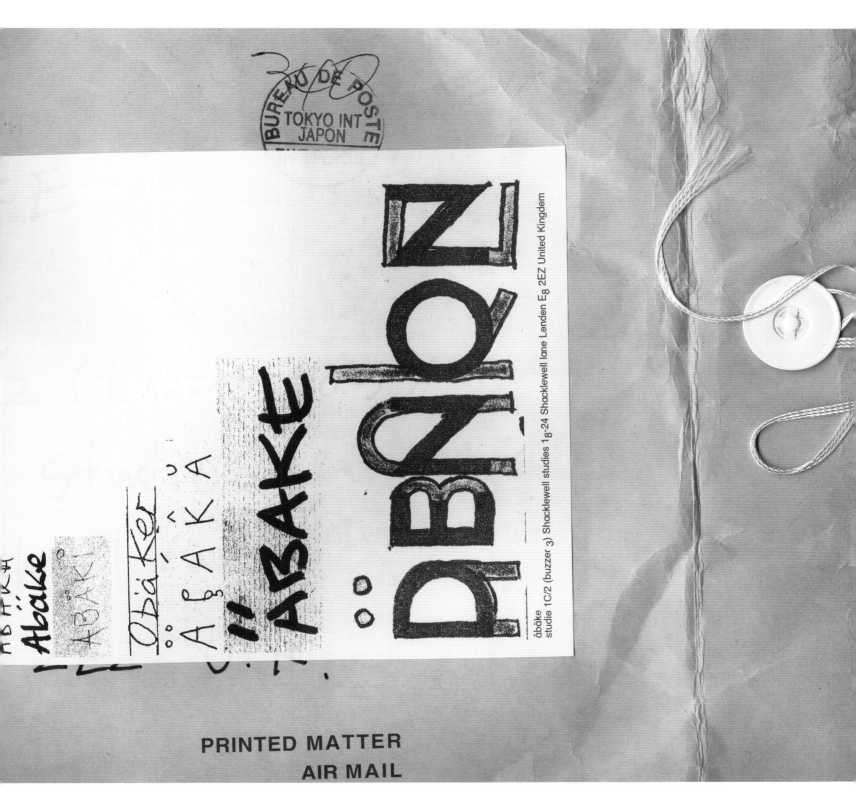

PRINTED MATTER

AIR MAIL

åbäke, address label, 2001
When corresponding with åbäke, people often misspell the studio's name. Deciding to make use of this recurring phenomena, they gathered these 'errors' and transformed them into what has now become åbäke's standard address label. This is not unlike the poster Robert Brownjohn created in the 1950s, 'A Return Exhibition of Graphic Design', which also catalogues postal error.

Alexander Gelman, Dave Heasty, Design Machine, Spread from *Agitate*, **2001**
Design Machine used their 'White' typeface for this spread from *Agitate*, the newsletter for the Alliance Graphique International. The typeface came about during a printing job that went wrong. Layout files for a mailer arrived at the printers without the display typeface, 'Black'. The resulting low resolution output (i.e. the mistake) created a pixelized typeface which Design Machine loved and called 'White'.

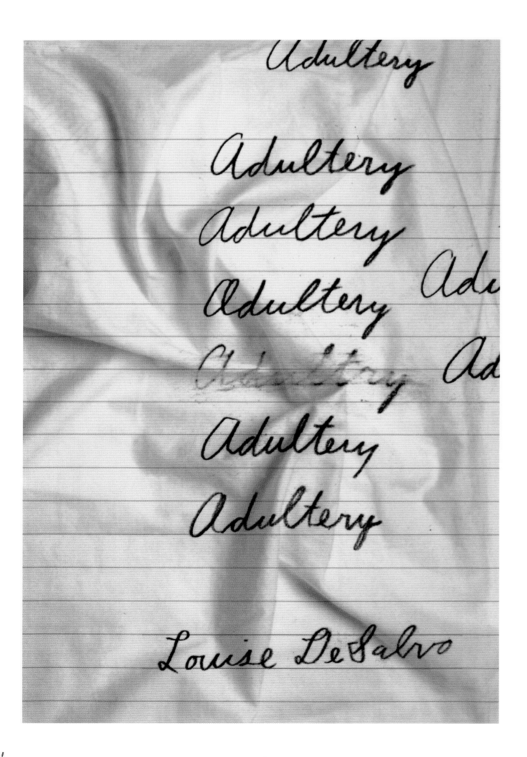

Paul Sahre, Office of Paul Sahre, *Adultery*, **2000**
As Sahre explains, the design for the book *Adultery* (Beacon Press) uses 'formal mistakes to communicate content'. In other words, the misspelling of 'adultery', becomes a visual rendering of the implicit message here: that adultery (or the episode referred to in the note) is a 'mistake'.

4 9:30IECMEETING13:00LUNCH14:30IECME
NKSANDDINNERTUE259:30NEWMEMBERSSE
UNCH14:30NEWMEMBERSSELECTION19:30B
RNEYSAVIGNACEXHIBITIONWELCOMEDRIN
NTREPOMPIDOUSEMINARINSEARCHOFEXCE
S:IRMABOOMWERNERJEKERJOHNMAEDAAB
:00LUNCH14:30PEDROPERETGUNTERRAMBO
9:30FIESTADANCEOPENFORNONMEMBERST
OTHEQUENATIONALEDEFRANCEWELCOMETH
'USOYEARSOFAGIVIDEORUEDIBAURPETERKN
13:00OPENINGEXHIBITION:LEGRAPHISMED
NT814:30FREE:ARCHITECTURALWALKSETC.
NOUCHEONTHESEINEDINNERPERFORMANCEF
ESSZAPPINGPIPPOLIONNIMADEBYCHILDR
ENCSTUDENTS13:00LUNCH14:30FREE17:30
INKS:ANATOMEGALLERYEXHIBITIONPARIS
TELDESULLYDINNERSHOWLESEXTINCTEURS
RESSGENERALASSEMBLYNEWMEMBERSAGI
ESULTSPROJECTIONSSM13:00LUNCH14:30
TBALLMUSEEFORAINSUN309:30DEPARTURE

In 1928, Alexander Fleming absent mindedly set
↙ (20.)
a laboratory plate containing staphylococci bact-

eria next to an open window. Later on, ret-

urning to the plate, he found that a mould had

grown on it. On closer inspection, he discovered

there was a clear zone around the mould: it was

dissolving the deadly bacteria. Howard Florey,

Ernst Chain, Norman Heatley and other re-

searchers at Oxford University further explored

Fleming's discovery and developed penicillin.

Multistorey,
We Never Make Mistaks, **2003**
For this special commission,
Multistorey spent six long hours, used
up countless black biros and incurred
some nasty blisters while patiently
colouring in the background of this
hand-rendered typographic slogan
(black ink on white paper). Aside from
having an ironically authoritarian air
to it, this witty visual gag highlights
the value of mistakes by choosing to
put one at the centre of the piece.

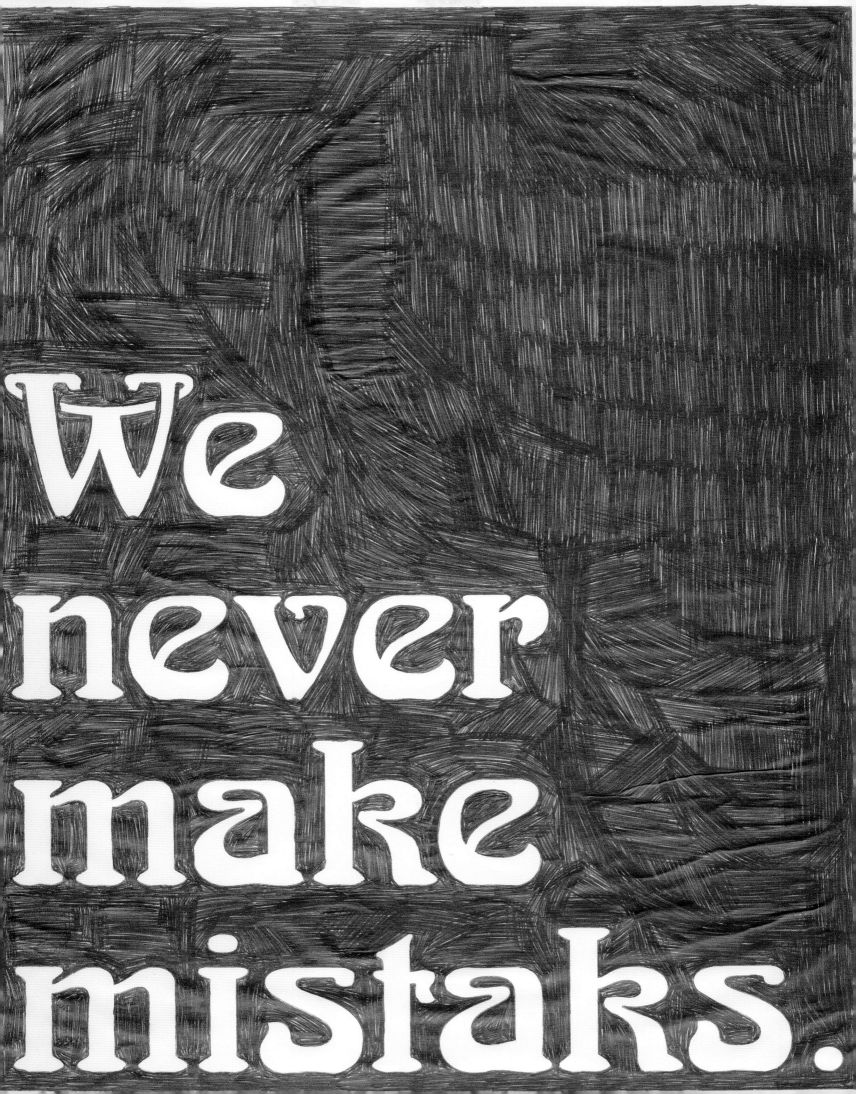

44.

i-D editor Terry Jones once said he doesnt like the idea of perfection because "it implies finality." In the late EightiEs, whEn i-D was gEtting startEd, JonEs EncouragEd his staff to switch jobS: photograpHErS would layout pagES, wriTErS wOuld TakE pHOTOS... inciTing aN 3n3rg3Tic ATmOSPHERE WHERE ANyTHInG cOulD HAPPEn.

This page

Allen Hori, Hard Werken, Subjective Reasoning, Equilibrium Vessel, 1992

'The basic premise for this promotional brochure,' Hori explains, 'was to look at the ideal states set up by nature and the disturbed states incurred by man. Each spread is composed of two images that set up this oppositional relationship. The image on the left of each spread is "man", the image on the right is "nature". All left images are printed mis-registered (disturbed lithography) while all right images are perfectly registered. There were arduous discussions with the printer in my wanting to intentionally print half the images out of register.'

Opposite page

Fabian Monheim and Sophia Wood, Fly Productions, Rest-O-Lounge menus, 2001

These menus, proposed for R Restaurant in Paris, used mis-registered photographs of flowers as their predominant visual. Different photographs were used on different menus to give the impression that a series of random mistakes had been made.

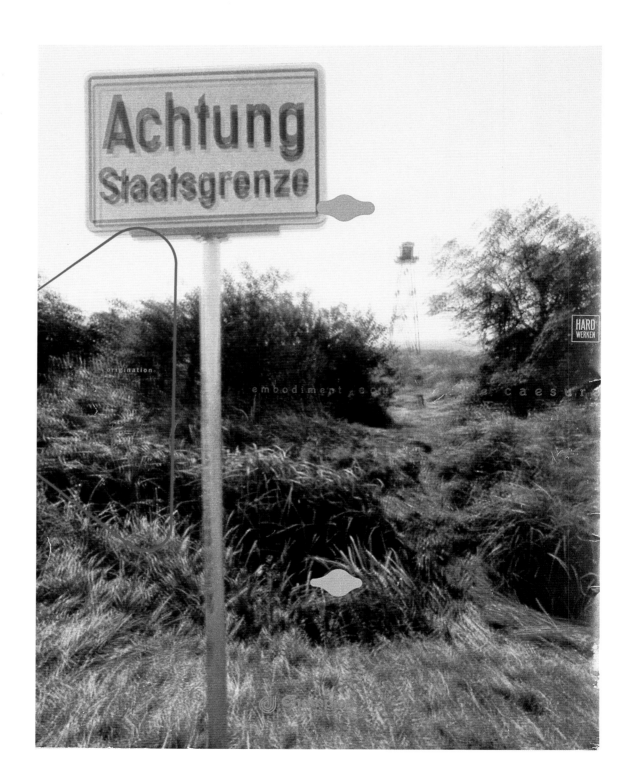

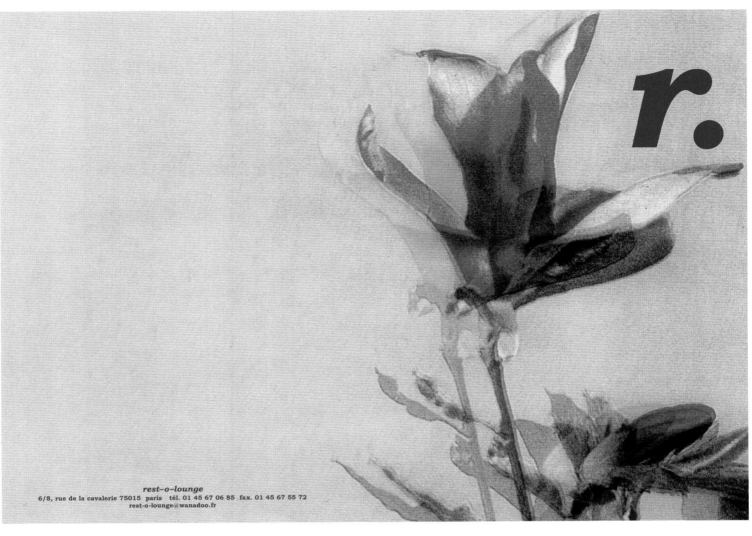

rest–o–lounge
6/8, rue de la cavalerie 75015 paris têl. 01 45 67 06 85 fax. 01 45 67 55 72
rest-o-lounge@wanadoo.fr

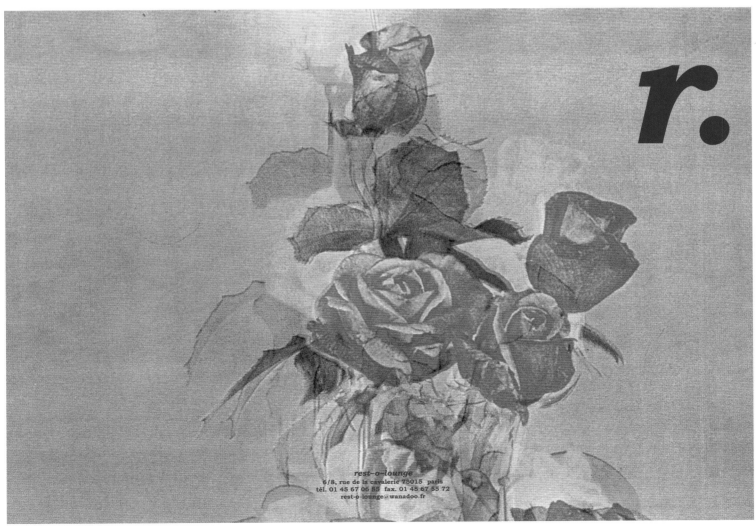

rest–o–lounge
6/8, rue de la cavalerie 75015 paris
têl. 01 45 67 06 85 fax. 01 45 67 55 72
rest-o-lounge@wanadoo.fr

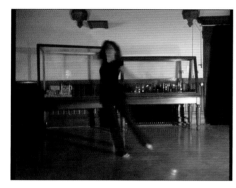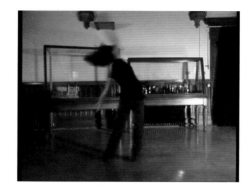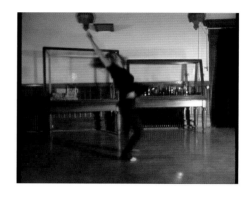
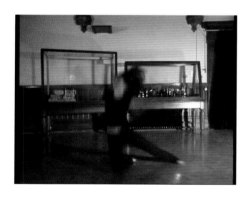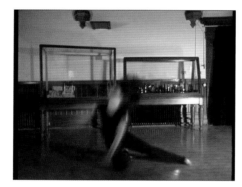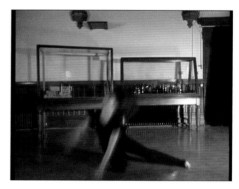
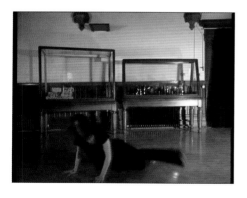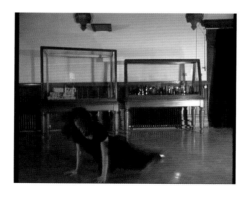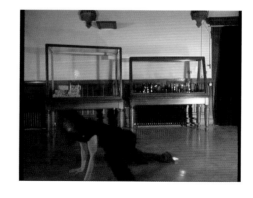

number 33. nick bell designed a moving card made of
in 1995, nick bell designed a moving card made of
unexposed photographic paper and posted them out in
black light-safe envelopes. when the card was taken
out of the envelope, the viewer saw bell's old address.
as the card was exposed to light, his new address (screen
printed onto photographic paper) gradually appeared.

**Alex Reuben, *Mistakes*, produced
for the Dance on Screen 2000 Film
Festival, 2000**

In this short film, dancer Vicky Udall
keeps trying to perform a dance phrase
only to abruptly fall to the floor each
time. 'She repeats the movement',
recalls Reuben, 'over and over without
stopping for six minutes. I wanted
to ask why we make the same
mistakes over and over again, both
as individuals in our personal lives
and collectively.' The incessant
repetition of what starts out as a
'mistake' ends up seeming like a key
part of the dancer's creative journey.

David Foldvari, Big Active, *Dazed & Confused* contents pages, 2000

'I was given the contents of the magazine,' remembers Foldvari of being approached by *Dazed & Confused* to illustrate the table of contents for an upcoming issue. 'I filled a sketchbook full of drawings and photocopies from what they gave me. The images from the sketchbook were then used to create these visuals. Some random elements, doodles, that came about whilst I was trying to work out what to draw next, and happened to be in my sketchbook also made it into the final images. In fact, I ended up relying on these random bits more for the final images than most of my intended work.'

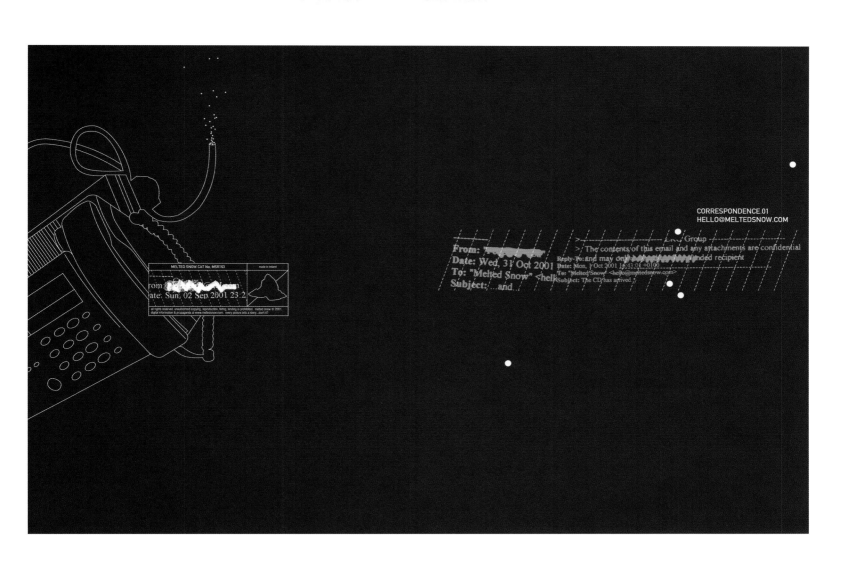

Peter Reddy, Redman AKA,
Correspondence.01, **2001**

For his book *Correspondence.01*,
Redman AKA employed what he
calls 'mistake qualities'. Although
the mistakes were intentional and
computer generated, he used them
to 'suggest some sort of "real" quality,
that somewhere in that equation a
"human" was involved'.

1. In spite of a legal dispute with the producer of his film FROST, which saw the master Reels confiscated, German film director Fred Kelemen, in fact kept 1 rough cut which he premiered at various Film festivals. Each time the film was shown, the print deteriorated. For many critics, the already grainy quality of the Film was only made better by this Accidental decay.

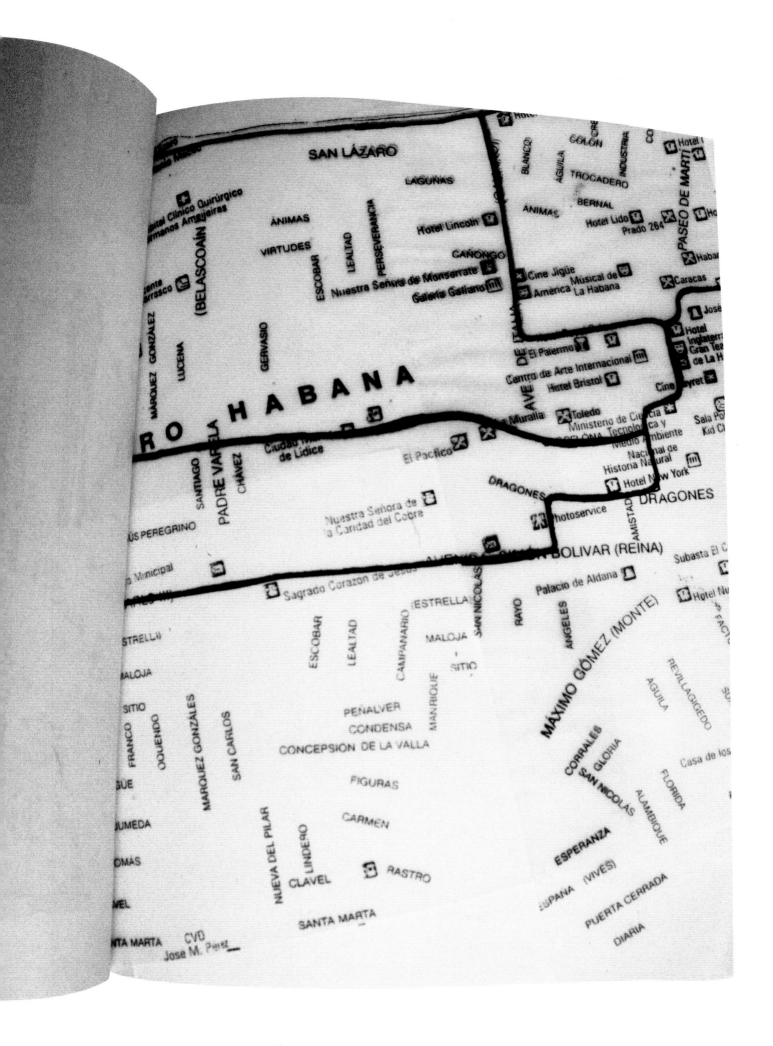

ons de Panxurge by US composer Frederick Rzewski was described
el Nyman as an 'interesting case of a kind of gradual process music
lt in allowance for failure. Rzewski's one-page score instructs peR-
to: 'Stay togetheR aS lOnG aS YOu Can, but if YOu GEt lOSt, StaY løST.
Y TO Find YOuR wAY bACk inTO ThE FOLd.'

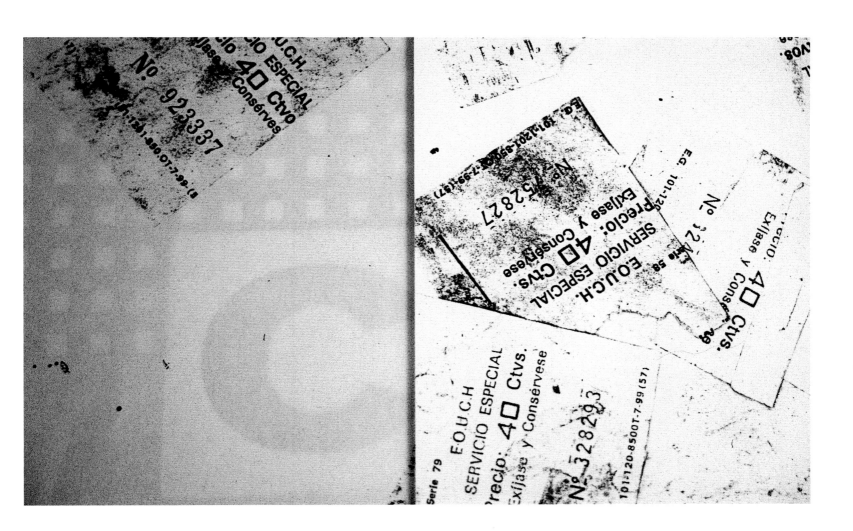

Anju Kathuria and Stephanie Weekes,
***Mistake* magazine, 2000**

While studying at Brighton University, Kathuria and Weekes were set a brief asking them to produce a magazine that demonstrated the creative role of the accident. After going to Cuba together, they designed this magazine using ephemera they had collected on their trip. The magazine, made up of photocopies that went wrong, distorted maps of Cuba, ripped bus tickets, binding which runs through the centre of the spread, was designed to the duo's mantra, 'If it takes several attempts to design one page, then all of them must be included.'

& There was once a 'printy' - one of those large photographic collages - at a David Hockney show that included a batch of fogged, spoilt prints in one corner, in the place where they would have gone had they turned out as planned. Pasted alongside them was a handwritten letter of apology from the local chemist, who was obviously very sorry to have messed up a job for a valued customer.

Darrell Gibbs, Sukie, One-off book of mistakes and trial prints, 1999
 This spread is culled from various mistakes that cropped up during a Sukie typography project. After finding the discarded work to have a value all of their own, Darrell Gibbs gathered the work as a one-off book of mistakes and trial prints.

WHAT'S FURNITURE?

WHAT IS REQUIRE?

WHAT IS A REAM?

WHAT ARE COUNTERS?

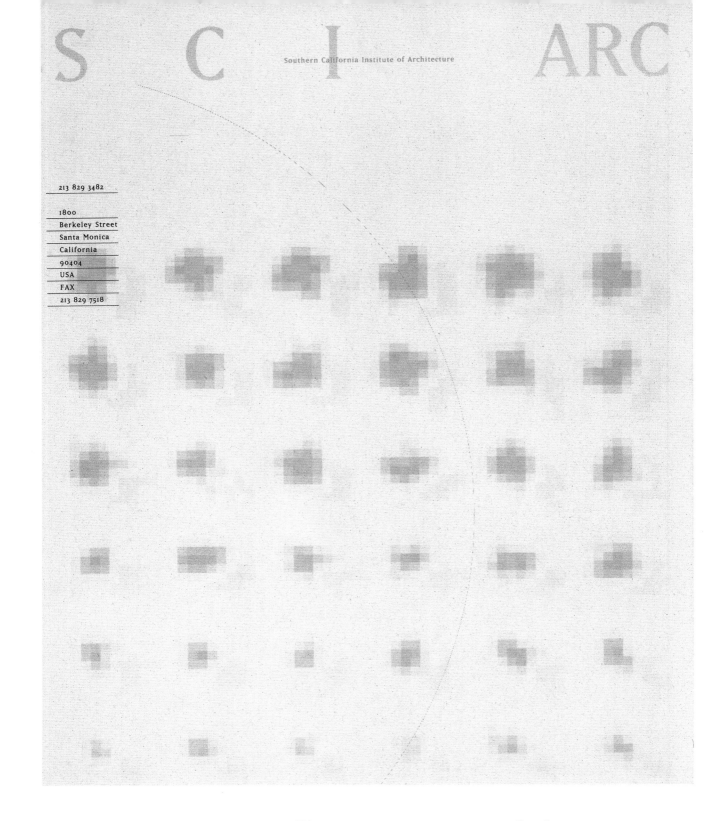

213 829 3482

1800
Berkeley Street
Santa Monica
California
90404
USA
FAX
213 829 7518

This page
April Greiman, Made in Space,
Sciarc Letterhead, 1989
'While working on a new identity
for Sciarc,' Greiman reflects, 'I was
reminded of working my first time on
a high-end paint box, and discovering
the "anti-alias" feature built into those
million dollar tools ... to avoid getting
"jaggy", pixelly imagery, it broke all
colors down into 16 million colors,
each with their own shades, hues. The
gradation which I scanned into that
paintbox, when enlarged up to many
thousands of percentage, broke each
little pixel into "iconic pixels" revealing
the "architecture" of the computer.'

Opposite page
Emma Thomas, Perfect Machine:
Registration poster, 2002
While a student at the Royal College of
Art, Thomas designed this process-led
project about mis-registration on a
lithographic proof press. Using two
colours (cyan and magenta), she
started by printing magenta as a base
grid of lines at varying widths. With the
consecutive overprints of cyan, Thomas
tried to hit exactly on the lines below,
as she says, 'in pursuit of the perfect
alignment'. The result of this mis-
registration unexpectedly resulted
in the appearance of the whole
colour spectrum.

Jenny Volvovski, *51 Geographical Perceptions of the World*, 2002

'I gave out a sheet of paper with the names of eight countries and one continent and asked university and high school students to draw each country as accurately as possible. The flaws in individual country drawings and the discrepancies between them become more important than the accurate geography of each place.' Embracing rather than rejecting the surprising number of mistakes, Volvovski compiled the results of the survey into *51 Geographical Perceptions of the World* (cover shown), a book that gives a whole new meaning to the phrase 'mistaken identity'.

An error occurred while processing

Error: ioerror
Command: readstring
Stack:

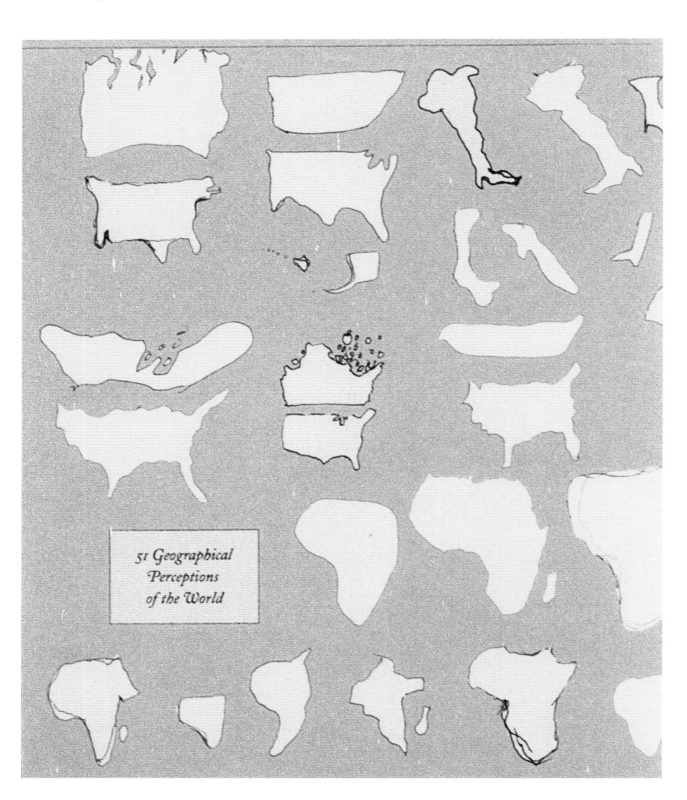

51 Geographical Perceptions of the World

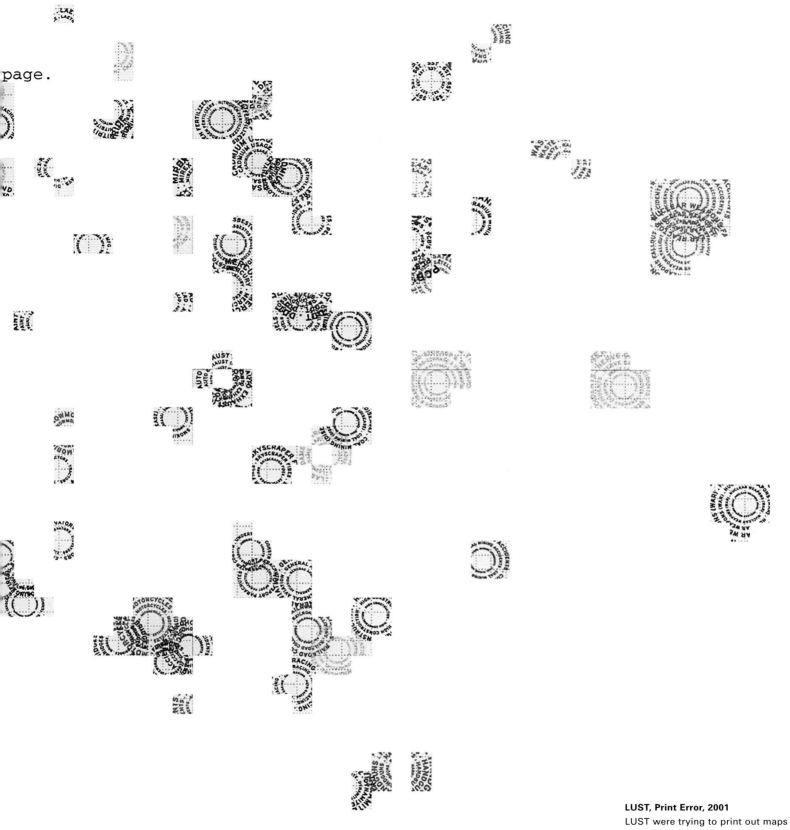

page.

LUST, Print Error, 2001
LUST were trying to print out maps when their printer ran out of memory, instead defaulting and printing out the Print Error shown here. In their opinion, this unintentional error was a 'new map' all of its own accord. They framed the prints (original size A3) and hung them on their studio wall. They now serve as original pieces of art as well as a source of inspiration.

Johnson

22} "Broken New York", by Kenneth Goldsmith and David Wondrich is a collection of broken ready-mades found on the streets of New York. Goldsmith and Wondrich's broken ephemera finds include a sprung vent plate, peeling duct tape indicating a broken door bell, and a bent back "No Standing" sign. "Broken New York" marvels at the imperfection of the city and elevates it to a blemished art form.

Dave the Chimp, Johnson Logo, 2000
'The Johnson logo was done about three years ago,' explains Dave the Chimp. 'It was one of about ten logo ideas for the band which they didn't use. I think it's based on the Wilson tennis company logo or at least the letter "s" is. It was hand drawn, scanned, streamlined, printed out and torn up, screwed up, then re-scanned.'

Ben Chatfield, Mistakes, 1999
In response to the brief of the same name (see below), Ben Chatfield borrowed a friend's sewing machine (he had neither sewed nor used a sewing machine before) and proceeded to sew found ephemera into a notebook.

Mistakes Brief
'From realizing that I can make mistakes, I have come to realize there is an order to what I do', Ornette Coleman, Alto Saxophonist, c.1950s

1. Select a medium that you despise or least like.
2. Push that medium outside the boundaries of what you can do, outside of what you already know.
3. Produce a language or a system from the wreckage.
4. Show everybody what you now know.

Brief written by Alex Reuben. Taught by Alex Reuben, Ian Wright and Frith Kerr at The London Institute, Camberwell College of Arts and Central Saint Martins College of Art & Design.

do not hesitate to contact
the store manager or
Woolworths p.l.c.
242 / 246 Marylebone Rd
London NW1 6JL

THANK YOU FOR
SHOPPING AT
WOOLWORTHS

Should you be dissatisfied
for any reason, please
do not hesitate to contact
the store manager or
Woolworths p.l.c.
242 / 246 Marylebone Rd
London NW1 6JL

THANK YOU FOR
SHOPPING AT
WOOLWORTHS

Bump, ICA Poster, 2000

Bump designed this poster for a Club Room reception at the ICA to look as though it was an architecturally accurate representation of the ICA buildings. Bump were flooded with letters from irate architects outlining in very precise detail the architectural inaccuracies of the drawing. One critic wrote, 'Your rendering is both clumsy and incorrect' and 'the use of rustication ... has been ridiculed into a multitude of worms', and finally and most amusingly, 'there is nothing fine or artful in this piece before me'.

The Club ICA The Mall London SW1Y 5A

19.00-21.00 RSVP; sarad@ica.org.uk T: 02

CAP GEMINI ERNST&YOUNG NESTA CHANNEL 4 THE ARTS COUNCIL GOLD

29.

Robert Rauschenberg's piece, *Accident* (1963) owes its name to a lithographic stone that kept breaking. The stone first broke during a trial proof. Rauschenberg then created another version of the work, which also eventually broke. He went ahead and printed the final proofs using the broken stone - celebrating (as opposed to denying) the beauty of the breaks and cracks that appear in the final print.

Zeel Industries, Turin Shroud, 2002
'I did these stencil-and-spraypaint-on-sticky-back-plastic stickers of infernal fruits for putting up in the street,' Zeel remembers. 'But when the stickers were packed together the hot weather made them stick to each other in my bag. A kind of scary Turin Shroud effect appeared as if by a miracle on the facing paper. Often in printing, a flaw in the method or technique can cause these aesthetic shifts and they have to be seized, enjoyed, exploited and learnt from instead of just discarded.'

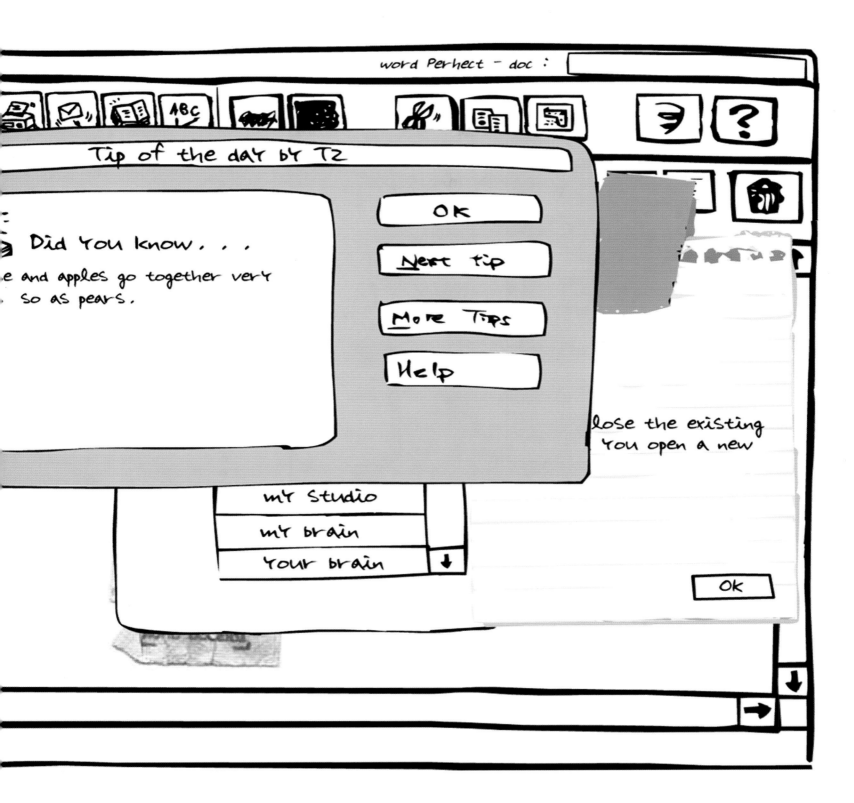

word Perhect - doc :

Tip of the day by TZ

Did You know . . .

e and apples go together very
so as pears.

OK

Next tip

More Tips

Help

lose the existing
You open a new

my Studio

my brain

Your brain

Ok

Tomoko Takahashi, *Word Perhect*, Technical Collaborator John Pollard, co-commissioned by e-2 and the Chisenhale Gallery, 2000

For *Word Perhect*, the online project by Tomoko Takahashi, users are given the choice between typing and handwriting, a messy and neat option. Windows open as hand-written notes taped onto the screen, complete with stains, rips and all the irregularities of masking tape. The project is laden with imperfections, all in an aim to challenge what can sometimes seem like the dehumanizing process of standardized word-processing software.

RIBA

 **Royal Institute
of British Architects**

Annie Spink Award for Excellence in Education

The President of the Royal Institute of British Architects has pleasure in inviting you to the presentation of the **Annie Spink Award for Excellence in Architectural Education** won jointly by **Peter Cook** and **David Greene**

Opened by **Sir Richard MacCormac** on **Tuesday 3 December** at **18.45** in the Jarvis Hall at the Royal Institute of British Architects 66 Portland Place London W1B 1AD

The Annie Spink Award is presented in recognition of an outstanding contribution to architectural education. Established in 1974 by architect Herbert Spink FRIBA, he endowed the trust as a lasting memorial to his wife Annie, who died in 1938. The award celebrates international achievement in architectural education, recognising excellence and encouraging an engagement with the process of teaching and learning.

RSVP
E miranda.housden@inst.riba.org F +44 (0)20 7307 3754
www.architecture.com

"Claw: Museum, Buenos Aires"

Annie Spink Award
Statement of intent
by Peter Cook

Even as a young architectural student in Bournemouth I was already fascinated by the range of discussions that could be made around a piece of architecture. Since the local public library seemed to have a number of books covering the architectural battles of the 19th century and early 20th century (Goodhardt-Rendel on the one hand and le Corbusier on the other) I started to recognise – through the tales about Romanticists and Classicists, Modernists and Revivalists – the links between motivation (even fanaticism) and powerful or definitive response in the actual architecture.

It soon became clear that function and material were not everything – even though I have since developed a cussed taste for ingenious or witty plans – and the complexity of design could be picked-apart and discussed through a web of motivations and sequences. As a student at the AA, I began to eavesdrop on more and more jury conversations: not only those of my own year, but practically any that were going on in the school. Of my teachers, Ronald Sims at Bournemouth and John Killick and James Gowan at the AA were exceptional: able in their own ways to flatter, cajole, intimidate, tactically unnerve and, most essentially, enthuse and inspire – usually just at the right moment. With Peter Smithson – my Thesis tutor – there came another teaching phenomenon: that of inspiration – by-example. I shall return to this aspect later.

I entered teaching by way of two years of 'critting'. Cheekily, having won a small competition, I wrote to John Winter (then 4th year master at the AA) asking if I could come on juries. During the next two years I seemed to be asked on to innumerable 4th and 5th year juries and in the end, got the sack from the James Cubitt office for spending too much time at the AA! What did I bring, I now wonder? I had not been a particularly vociferous student – more a 'grafter' I suspect. But I am passionate about architecture. Its foibles and byways as much as its enduring principles or great thrusts. Even then, I was fascinated by the ways in which learned method, imitation, displacement activity and common-sense get interwoven. Gradually I taught myself to interpret drawings and

David Greene and Peter Cook's combined list of distinguished students include:

Will Alsop
Alsop Architects

Professor Ron Arad
School of Architecture and Design, Royal College of Art

Juliet Bidgood, Liza Fior
Muf

John Bell
Senior Officer for Architecture, Arts Council of England

Andrew Birds
Birds Portchmouth & Russum

Catherine Burd, Buddy Haward
Burd, Haward and Marston

Anne Boddington,
Head of School of Architecture and Design, Brighton University

Professor David Chipperfield
David Chipperfield Architects

Nic Clear
General Lighting and Power

Mike Davies
Richard Rogers Partnership

Professor Kathryn Findlay
Ushida Findlay

Sean Griffiths
F.A.T

Tony Fretton
Tony Fretton Architects

Marco Goldschmied
Richard Rogers Partnership

Piers Gough
CZWG

Nicholas Grimshaw
Grimshaw

Professor Sand Helsel
Faculty of Architecture and Design, RMIT, Melbourne, Australia

Amanda Levete
Future Systems

John Lyall
John Lyall Architects

Sally Mackereth
Wells Mackereth

Keith Priest
Fletcher Priest Architects

Professor Peter Salter
University of East London

Professor Leon van Schaik
Pro-Vice Chancellor, RMIT, Melbourne, Australia

Alex de Rijke
Architectural Association and DRMM Architects

Katherine Shonfield
South Bank University

Alan Stanton
Stanton Williams

Peter St John
Caruso St John

Morely von Sternberg
Architectural Photographer

Professor Ken Yeang
T R Hamzah and Yeang

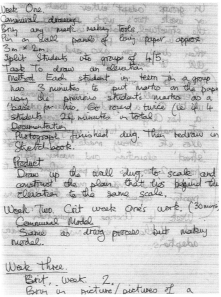

Studio Myerscough and Simon Pickford, RIBA Annie Spink Award, 2002

The invite to the 2002 RIBA Annie Spink Award (opposite page) and the spreads from the awards programme (this page) share a rough-hewn, yet sophisticated visual language, made up of everything from re-photocopied documents, handwritten notes to hand drawn typography to create, as Studio Myerscough explain, 'a handmade document that feels like a collection of notes, ideas and thoughts'.

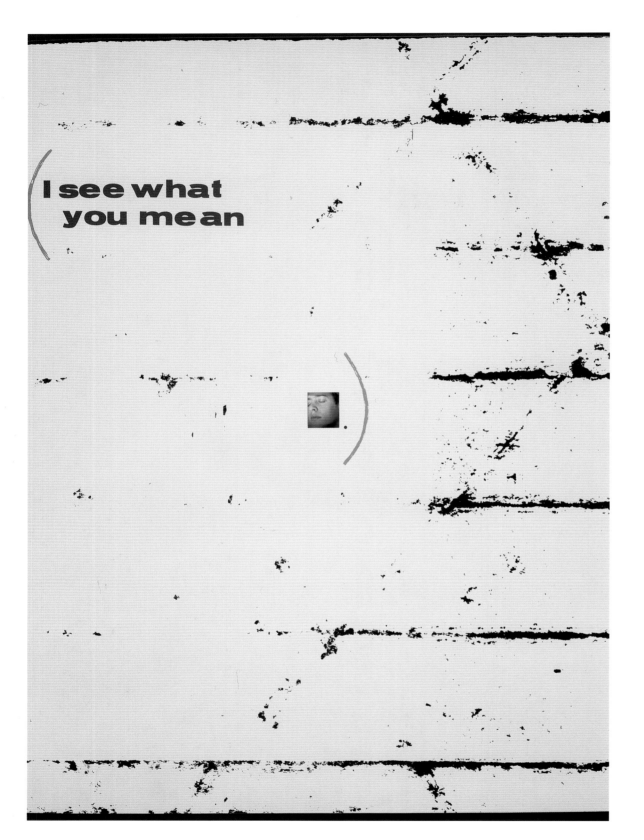

I see what
you mean

MISTAKE

THINGS THAT I BOUGHT BY MISTAKE

① pink skirt, supermarket ●
boyfriend thought I look fantastic in and
convinced me to buy it and it is unfortunately
very tight on me to walk around

② Converse shoes
I was wearing a pair of uncomfortable shoes
then, so I bought the cheapest shoes that
I could find that time. These are not ●
my style.

③ Brown skirt
It has got very ugly shape

④ Brown suede shorts
These are so ugly but are from my mum,
so I have to have them.

⑤ Blue dress / charity shop
It thought It was fabulous but it is
very over the top ●

⑥ Boxer shorts

⑦ pink leggings
These are pink, very bright pink.

⑧ Small blue duvet
I thought I would make something out of this,
but I did not do anything.

⑨ Korean wallet
It does not have coin pocket, so useless,
but pretty, though.

⑩ blue stripe Tshirts
once again I bought it, because it was
cheap ●

⑪ white woolen scarf
It was cheap, but it is heavy to wear ●

⑫ little wooden box / antique shop
I bought it for a project in foundation, but
did not use it the end, but I did not
bother to exchange to something else.

⑬ Scotty red jumper / charity

⑭ Big snob bag
As it says in front of it,
snob bag. ●

⑮ 1940s dress
It is a fantastic dress, bu
it is so small. It is a thin
though.

⑯ Ralph Lauren trousers ●
These are very nice, but ne
I thought I would loose we

⑰ Black sequence top
too short.

⑱ Brown top

⑲ Blue jumper
very confi, but ugly. I do n

⑳ chinese top
I quite liked the horrible q
I bought it, but it is hor

㉑ White wooden cape
cheap and cute, but very b

㉒ a pair of silver earings
So heavy to weare and ears

㉓ flower printed red dress
so cute print is on and
but it is over the top.

㉔ Fanny, the book / Erica Jong
It is difficult to read, and
the real meaning of "Fanny",

㉕ Orange Jacket / Esprit
The colour is awful for me

26 Schloss / Kafka
Because I studied German, I thought I should read it in German. It would take ages to read with an dictionary.

27 Sun block lotion / Kookäi
I bought a wrong one. I wanted to get sun tan lotion.

28 Sunday Times / 14. Nov. 1999
Boyfriend thought it was time me to start to read newspaper, so he convinced me to buy and forced me to read it. Unfortunately it was difficult to read for me.

29 Black hat

30 gray shitty trousers
As it says, it is shitty.

31 Shelters Mantra—Album
It was recommended by a shop assistant, who I used to fancy, so I bought it, but realized that I did not like it.

32 Smaship Pumpkin-Album
I did not read properly what it said on the cover. It says it is an interview album.

33 Lap top computer

34 Black shoes
I bought them in Korea, because they were useful there, but not in London.

● These are the items that I bought, because these were cheap, I thought.

● These were the items that I was convinced to buy by other people.

Chosil Kil,
Things I Bought By Mistake, 2001
Chosil Kil, as part of a self-initiated project, made a list of all the things she had ever bought by mistake. ~~Chosil Kil, as part of a self-initiated project, made a list of all the things she had ever bought by mistake. Chosil Kil, as part of a self-initiated project, made a~~

DO TI YOURSELF

This page
Ian Chilvers, Atelier Works, *DIY*, 1985
'I placed randomly selected sorts from a nearby type case and then lightly locked them into a chase with a little less diligence than usual,' Atelier Works recall of this project for newly founded record label DIY. 'I just needed a quick pull to begin thinking about what I'd do with the letters. On the first pull I had my solution. The accidental transposition of the "T" and the "I" summed up DIY, all those good intentions usually result in something else.'

Opposite page
Michael Bierut, Pentagram, New York, *What is Good Design?*, 1992
The lettering on the American Center for Design poster was done by Bierut's pre-literate four-year-old daughter, Elizabeth Ann Bierut. In Bierut's own words, 'all mistakes were preserved as recorded on the first try'.

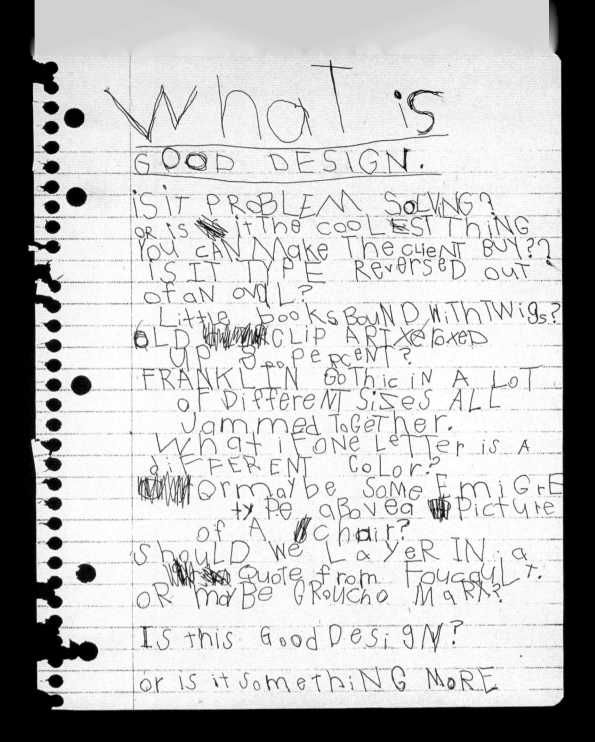

What is

GOOD DESIGN.

IS IT PROBLEM SOLVING?
OR IS IT THE COOLEST THING
YOU CAN MAKE THE CLIENT BUY??
IS IT TYPE REVERSED OUT
OF AN OVAL?
Little BOOKS BOUND WITH TWIGS?
OLD CLIP ART XEROXED
UP 5 PERCENT?
FRANKLIN GOTHIC IN A LOT
OF DIFFERENT SIZES ALL
Jammed TOGETHER.
WHAT IF ONE LETTER IS A
DIFFERENT COLOR?
OR MAYBE SOME EMIGRE
TYPE ABOVE A PICTURE
OF A CHAIR?
SHOULD WE LAYER IN A
QUOTE FROM FOUCAULT.
OR MAYBE GROUCHO MARX?

IS THIS GOOD DESIGN?

OR IS IT SOMETHING MORE

CALL FOR ENTRIES
THE FIFTEENTH ANNUAL AMERICAN CENTER FOR DESIGN
ONE HUNDRED SHOW

ALEXANDER ISLEY, JILLY SIMONS, ERIK SPIEKERMANN, JUDGES
MICHAEL BIERUT, CHAIR

ENTRY DEADLINE: MAY 1, 1992

DESIGN: MICHAEL BIERUT / PENTAGRAM
LETTERING: ELIZABETH ANN KROSZ BIERUT / TRANSFIGURATION SCHOOL

This page
Kenn Sakurai, Dave O'Regan, Mary-Lou Hewlett, esm-artificial, untitled, 2002
'While we are printing, when we screw up a colour, we print on a scrap piece of paper just to re-flood the screens,' explain esm-artificial. 'One day a friend was looking at the various sizes and colors of scraps in this bin and said, "These look kinda' neat."'

Thereafter, esm-artificial and their friend embarked on an 'accidental collaboration' to rescue test print sheets from the bin and re-contextualize them as works in their own right.

Opposite page
Scott Santoro, Worksight, Greetings from Emily Scott Ozzie Worksight Holiday Card, 2000
'The card's photo was taken while purchasing our first Christmas tree,' Scott Santoro explains. 'After I shot that I made a call from a phone booth and there was this beautiful scribbling on the inside wall. It was a crossed-out block of telephone numbers and names, but I also saw it as a tree of information. It seemed perfect when I placed it over the photo of trees I had photographed.'

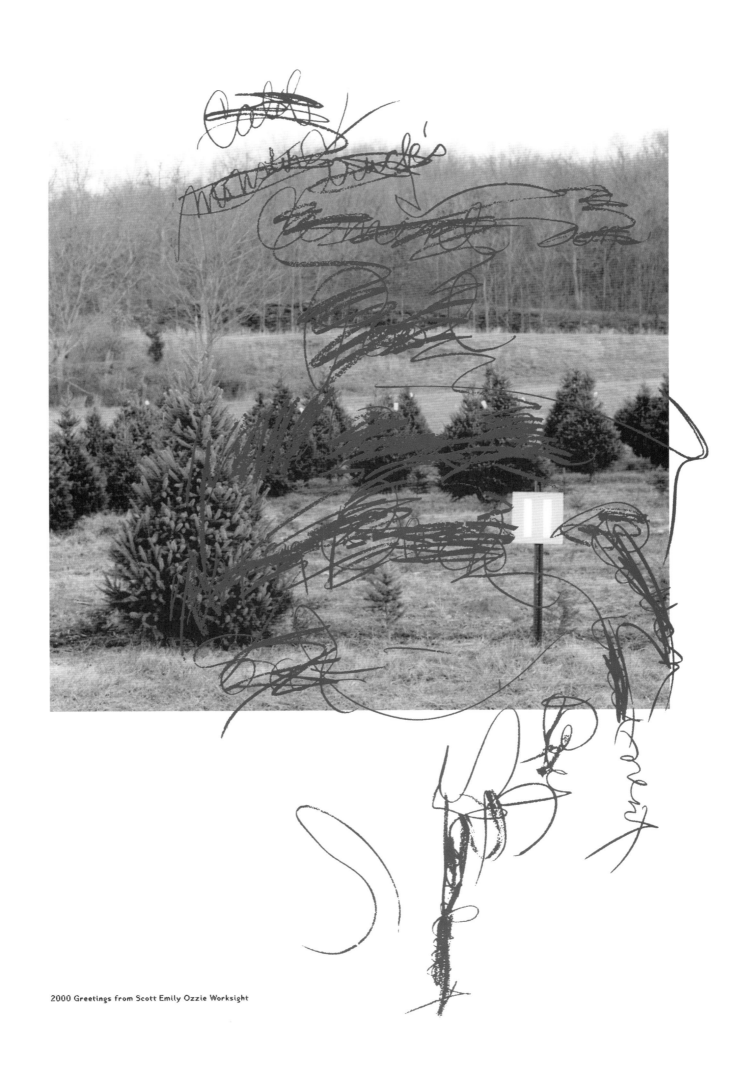

2000 Greetings from Scott Emily Ozzie Worksight

search
destroy

FELLS POINT
CORNER THEATRE
MAY 7 – JUNE 13
BY HOWARD KORDER
BALTIMORE PREMIERE JOHN BLAIR DIRECTOR
TICKETS 276-7837
& INFO

Opposite page

Paul Sahre, Office of Paul Sahre,
Make-Readies, 1992–2002

This is part of a series of posters for
which Paul Sahre silk-screened some of
his own work onto make-readies that
he has collected over the years. ~~This is~~
~~part of a series of posters for which~~

This page

Designer: Nick Bell, UNA (London);
art director: David Stuart; CD cover
for Decca Records, 1993

For this CD cover, Nick Bell wanted to
visually represent the music, 'Charles
Ives's music features the layering
of contrasting and often conflicting
genres of music.' To reflect this, Bell
raided the print workshops at the
London College of Printing for their
press set-up sheets. 'These were A2
sheets the press-minders had been

using for years test-printing whatever
was on the press in layer after layer
of text and imagery. Actual size details
were taken from these using a CD-
sized viewing frame. These were then
put aside whilst the typography was
designed without these in mind. The
two were then brought together to
produce the final design.'

Tobias Toyberg-Frandzen,
Transformer, **2003**
While editing his video, *Transformer*,
Toyberg-Frandzen used the wrong
Quick-Time setting to export his
original file, causing the stills to be
disturbed by lines and bit-maps.
Preferring the software-induced error
stills to what he intended, he included
these 'mistakes' as part of the final
video alongside the originals.

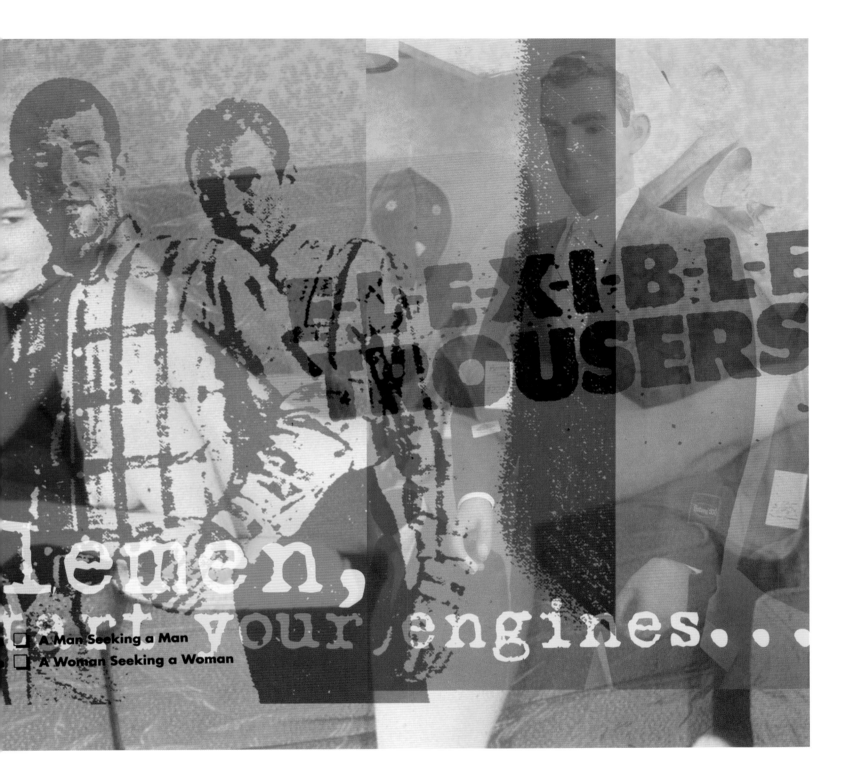

FLE·X·I·B·L·E TROUSERS

Gentlemen, start your engines...

☑ A Man Seeking a Man
☐ A Woman Seeking a Woman

Neil Edwards, Mr Edwards,
Gentlemen Start Your Engines, **2001**
'I embrace mistakes and accidents in
my work,' admits Edwards, 'because
I grew up working on a low-budget
i-D magazine, no computers, no
proofs. Watching the magazine roll
off the press was always a surprise.'
Of the self-initiated work shown here
Edwards says, 'My inspiration was
from the run-offs from printers,
which I collect because they produce
completely random results ... the
kind of results that no one would
ever dream of "designing".'

Paula Scher, 'The World' map painting, 1998

'I began painting complicated maps', says Paula Scher of her cartographic explorations, 'as an antidote to the long-term boring corporate identity projects that I was working on. The terrific thing about painting the maps is that I'm totally in control of all of the information and can put things anywhere I want, make spelling mistakes and not bother to correct them. I like it when people walk up to a large map of the United States, point to a spot and say, "That's where I was born." Of course they weren't. It's in the wrong place but it's sort of right.'

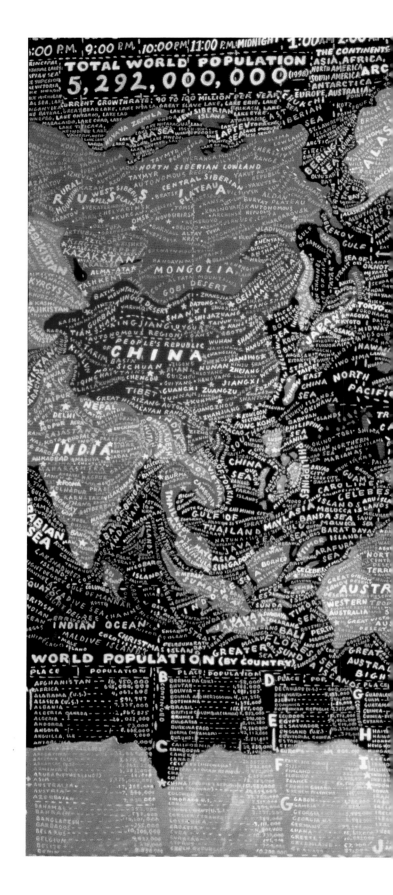

24/ Disc, a San Francisco based collective, was founded in 1997 on the basis that there are too many CD's in the world. In an attempt to remedy this, Disc randomly picks CDs and uses razor blades, markers, lubricants, microwave ovens to damage them. Once damaged, the altered CDs get put through CD players - skipping freely - allowing for the CD player to compose an alternate piece of music.

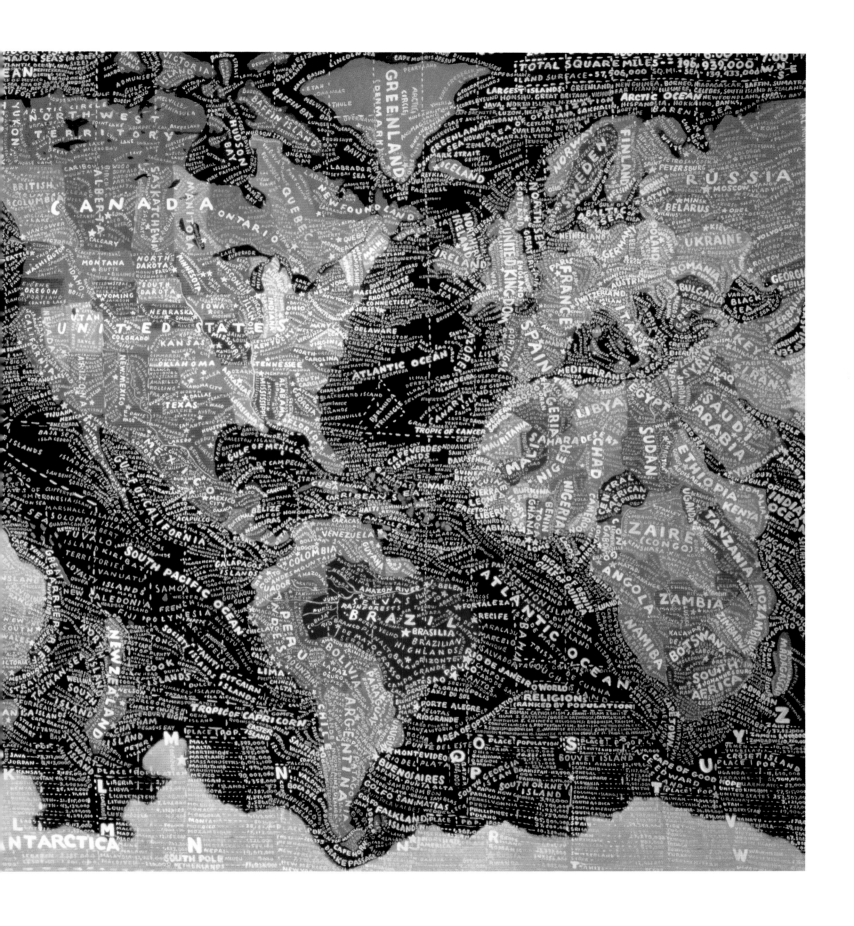

73

La frontera del infierno

La ribtijksjlfhjjkdjjhhjlesdjjjejejslbfu kkkkkkkkkkkkkkkkkkkjjjwkwje
jjejejejejejejejejdjeijf

The Spanish invasion of what was to become Mexico began in the 16th
century. Bands of soldiers, priests and adventurers did battle with
the approximately 25,000,000 Indians there in order to claim the land
for Spain. Hernan Cortes, one of the best known of the conquistadores,
exploited divisions between Indian tribes and managed, with only a
small band of men, to conquer the Aztec empire, located in and around
what is now Mexico City. This and other conquests led to the mixing
of Spanish and indigenous blood, spawning los mestizos, the first Mex-
icans. In the border region, off spring of los mestizos became the
first Chicanos.

In the mid-19th century, the United States provoked a war with Mexico,
abd seuzed cibtrik if nycg if tge ciybtrtL kabds tgat became

In the mid-19th century, the United States provoked a war with Mexico,
and seized control of much of the country: lands that became New
Mexico, Texas, Colorado, Arizona, and California. The U.S.*Mexico bor-
der was relocated 100 miles south, from the Nueces River to the Rio
Grande. The Treaty of Guadalupe-Hidalgo, signed by Mexico and the United
States in 1848, brought with it the first border barrier, a fence that
summarily entrapped more than 100,000 Mexican citizens on the U.S.
side. Certain territory that was supposed to be property of these Mex-
icans was illegally appropriated from them, making a tragic joke out
of the treaty.

15.
Auto-illustrator, a "self design" tool by
Adrian Ward, is an automatic verision of the
vector-based graphics program, which like "Word
Perhect", challenges our idea of "perfect" pro-
gramming. Messages like 'there are no options
for this tool - boring - choose another one"
appear, options for drawing shapes are "childish,
adult, artistic", and probably best of all, you
can "squash" bugs and affect their behaviour:
"nervousness, attention, maturity, distraction."

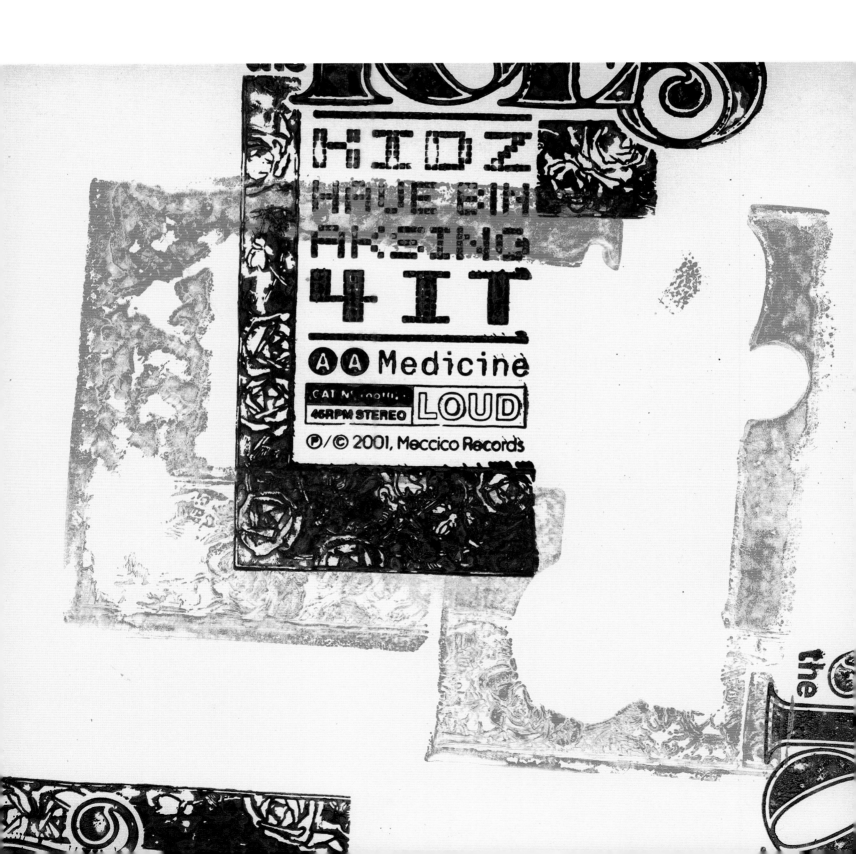

KIDZ
HAVE BIN
AKSING
4 IT

Ⓐ Ⓐ Medicine

CAT N° 00111
45RPM STEREO LOUD

℗/© 2001, Meccico Records

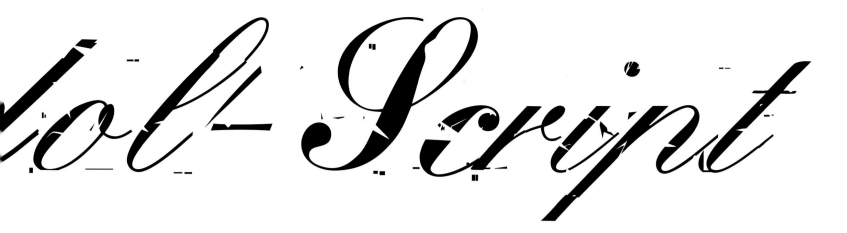

dol—Script

Above

Jonathan Barnbrook, Barnbrook Design, False Idol, 1996

False Idol is a typeface based on bad rubdown lettering *en hommage* to 1970s' pornographic magazines. Available in both plain and script, script (which has a sort of 'seedy glamour' to it) is shown here.

Left

Robert Green, The Toes – Kidz Have Bin Aksing 4 lt c/w Medicine, 2001

'The whole job was a balls up from beginning to end,' says Robert Green of designing this 7" single sleeve for The Toes. 'The record company ordered the wrong sleeves, so the ink wouldn't adhere properly to the coated stock. The rubber stamps couldn't be produced at a large enough size, mainly because of money, and me and the band stayed up until three in the morning printing the buggers.'

4.

One night, while editing Faces in the make-shift editing suite at the Cassavetes home, John Cassavetes' mother-in-law Lady Rowlands, accidentally let her French poodle loose. The dog emptied his bowels all over an entire roll of film. The unruly dog played what turned out to be a crucial role at a critical stage in the editing process of the film.

Rosie Irvine, *Red Lady,*
Girl, Thinking, **2002**

'I began to work this way when
I accidentally photocopied one
final piece on top of another,' says
Rosie Irvine of the work shown here
that exemplifies the role that recycling
and the reappropriation of discarded
pieces plays in her creative process.
'I realized that the accidental
composition looked a lot better than
the original. I now have a paper file
as opposed to the bin, full of cuts,
photocopy mistakes, print-outs,
different textures, dead stencils, etc.
for me to dip into. I've found that
working this way allows me to
produce fresher pieces.'

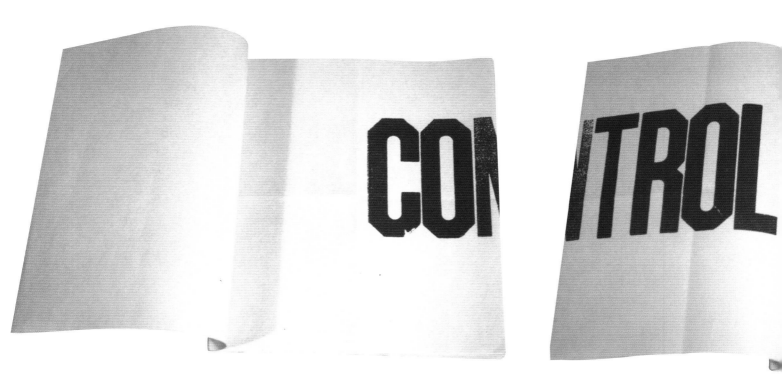

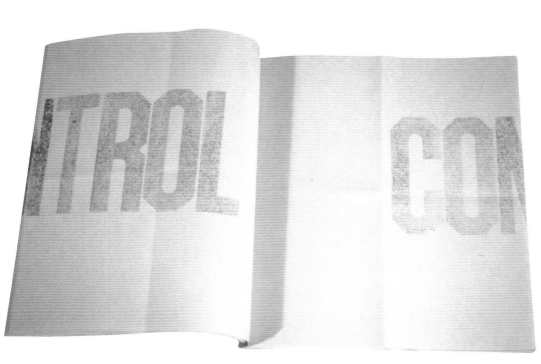

3º.ARTIST KEITH TYSON USESES WHAT HE CALLS THE ART

HIS WORK.THE MACHINE IS AN ELABORATE EQUATION W

INFORMATION INTO IT AND FROM WHICH HE RECEIVES COMM

UNPREDICTABLE WORKS OF ART.

Rebecca Klein, *Control* book, 2002
For this work, Klein printed on a
letterpress until the ink ran out.
In doing so, she says that she 'let
the process control the visuals and
the book's form, its length and
ultimately its destiny.'

HINETOGENERATE

TYSON FEEDS

ONS FOR COMPLETELY

This page
Paul Elliman, Bits font, 1999
Paul Elliman based his Bits font (for
Fuse) on a bag of junk/found objects
that he used to carry around with him.
Even though Bits has been scanned
and digitized, Elliman has made sure
that the set continues to decay and
deteriorate, staying true to the
authenticity of the objects.

Opposite page
Lawrence Zeegen,
Random World, 2002
For this special commission, Zeegen
kept an open Freehand document on
his desktop while working on four
other illustration commissions.
Working 'blind', he placed, at random,
invisible (white) images onto a white
background over the course of one
month. At the end of this set time
period, he turned the background
black, making the piece visible, to find
that random elements from the four
commissions had created a fifth piece.

SEE HOW
EASY IT IS
Step by Step !

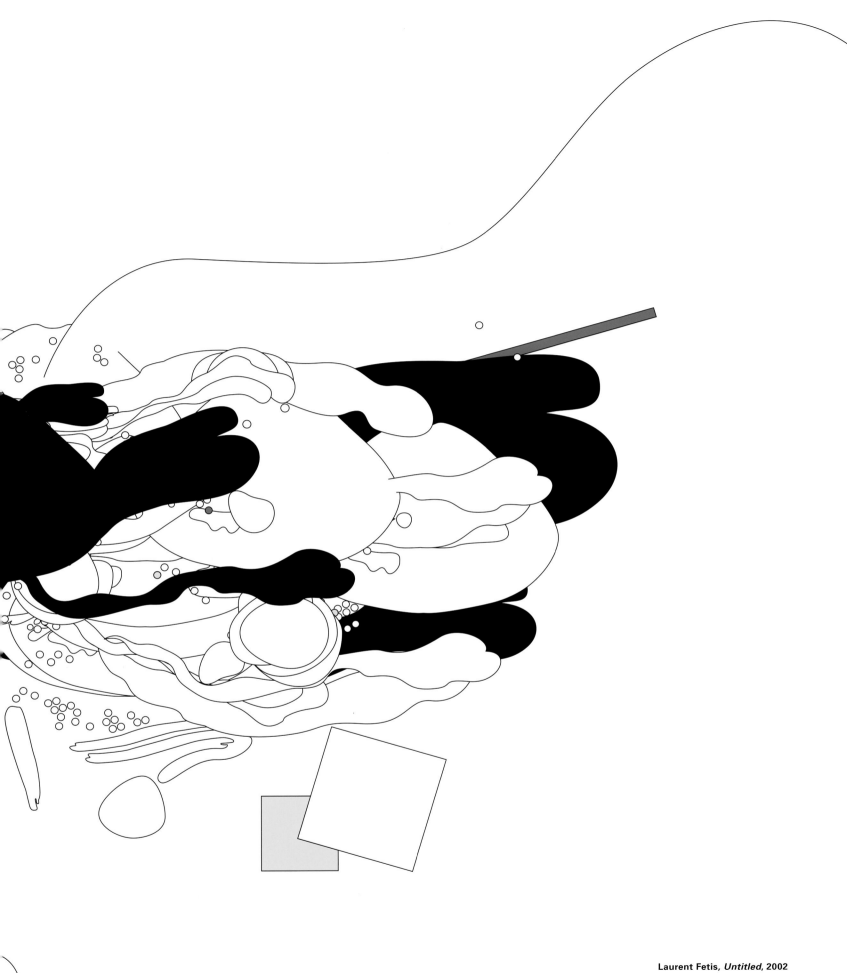

Laurent Fetis, *Untitled*, **2002**
For this special commission, inspired
by the Rorschach Test (a type of
outmoded psychiatric assessment
method based on ink blots), Fetis
places accidental form at the centre
of his sprawling piece.

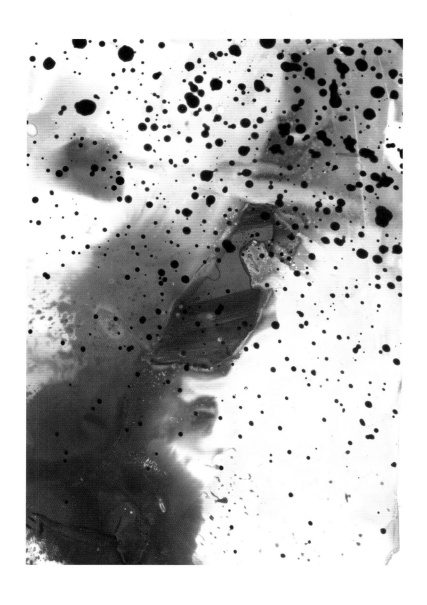

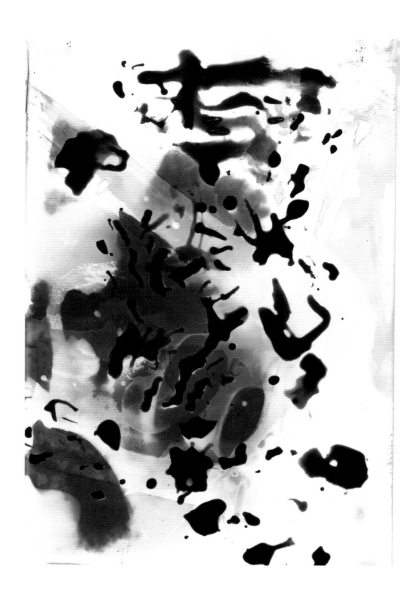

Left
Jonathan Milott, Honest,
Ink Blots, **2001**
After deciding to drop the name
Agenda in favour of Honest, the
studio designed the *Ink Blots* image
shown to visually represent their
new name. The ink blots, like the
Rorschach Test that inspired them,
can be seen as an interpretation
of accidental forms.

Below
Rosemary Smith,
004, 003, 001, 002, **2002**
'Process, scale and form are introduced
by exploding objects to huge
proportions on the enlarger,' says
Rosemary Smith of these photographs
which take found, collected and
manipulated materials as their subject
matter, 'whilst reducing others to
simple and abstracted marks through
composition and space.'

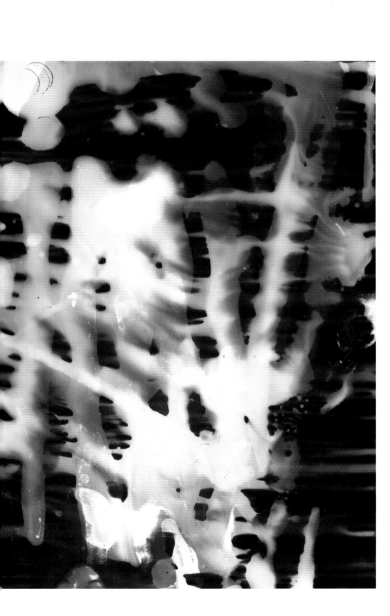

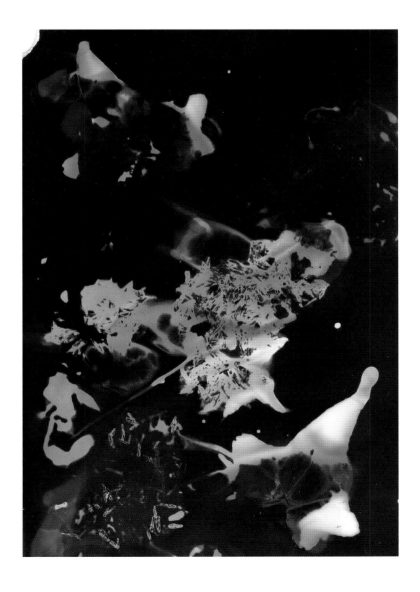

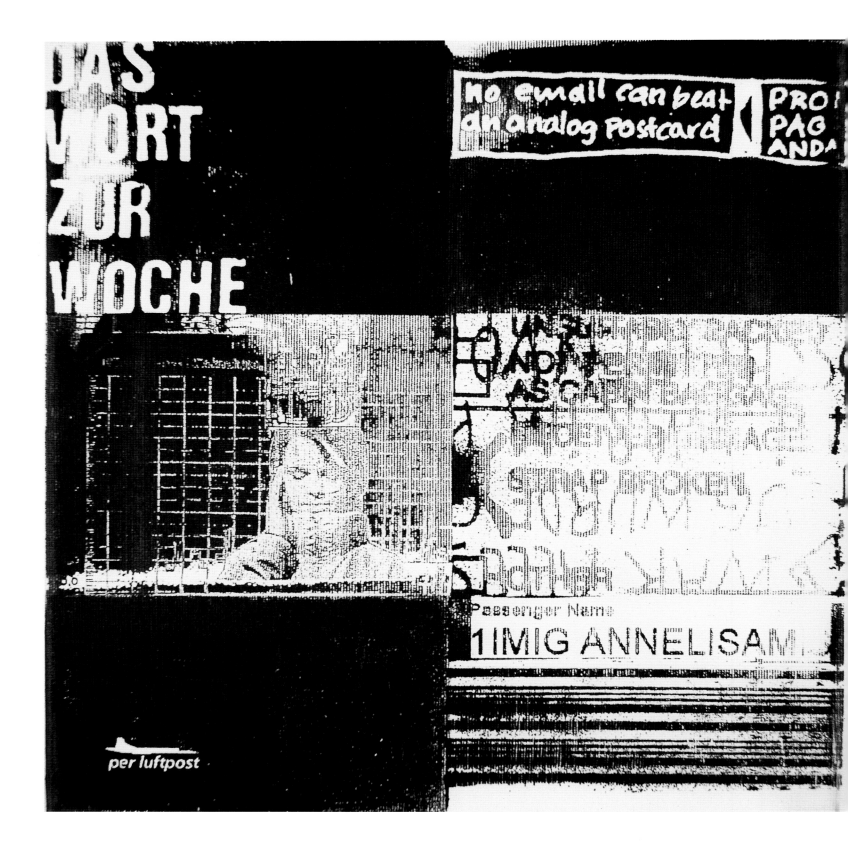

This page
Anne Imig, with illustrations by Martin Rathscheck, *No email can beat an analog postcard*, 2002
This work comprises details randomly plucked from an extensive series of postcards that Imig and Rathscheck exchanged over a fixed period of time. The collated visuals were then screenprinted onto canvas.

Opposite page
Bark Design, Bark Books, 1998
The idea for Bark Books was to create an 'alternative' portfolio to show the way Bark work, instead of relying on a traditional portfolio that showed their body of work to date. Bark Books compile random compositions of self-initiated work, client-based work and found pieces. In Bark's own words, 'It is a very exciting and refreshing way of working. The books have a particular hybrid dynamic that is a direct result of combining considered design with a random factor.'

November 1974 THE NORTHWOOD COVENANTERS

THE NORTHWOOD COVENANTERS

SUN 24 MAIN MEETING 3.00
Tue 26 Indoor Soccer 6.15
Thu 28 Swimming 6.10

Inters (1975-1987) Programme, November,

Thu 7 Swimming 6.10 Games Evening 7.30
 with Parents
SUN 10 MAIN MEETING 3.00 X-Country Run 1.30
Tue 12 Games Evening 6.15 Mon 17 Sailing (13+) 9.30
Thu 14 Swimming Tue 18 Indoor Games 7.30
Fri 15 Christmas Thu 20 South Ruislip 2.00
Sat 16 Market 10.30 Sat 22 MAIN MEETING 3.00
SUN 17 MAIN MEETING 3.00 Games Evening 6.15
Tue 19 Games Evening 6.15 Swimming 6.10
Thu 21 Swimming 6.10 Sailing (13+) 9.30
Sat 23 Soccer 9.30 Thu 27 Soccer 6.15
Sat 15 Soccer Burnt Oak 2.00 Sat 29 X-Country Greenford 2.00

On weekdays we meet at Emmanuel hall, High St. Northwood
On Sundays at the Boys' Club, 54 Hallowell Rd. Northwood

November 1974 THE NORTHWOOD COVENANTERS

Inters Programme

SUN 24 MAIN MEETING 3.00
Tue 26 Indoor Soccer 6.15
Thu 28 Swimming 6.10

Tue 5 Games Evening 6.15 Senior Programme, November 1975
Thu 7 Swimming 6.10 GAMES EVENING 7.30
SUN 10 MAIN MEETING 3.00 WITH PARENTS
Mon 3 Games Evening 6.15 SUN 16 X-Country Run 1.30
Tue 12 Games Evening 6.15 Sailing (13+) 9.30
Thu 14 Swimming Wed 19 Soccer 6.15
Fri 15 Christmas South Ruislip 2.00
Sat 16 Market 10.30
SUN 9 MAIN MEETING 3.50 MAIN MEETING 3.00
SUN 17 MAIN MEETING 3.00 Games Evening 6.15
Tue 19 Games Evening 6.15 Swimming 2.00
Thu 21 Swimming 6.10 Sailing (13+) 9.30
Sat 23 Soccer v 9.30 Sat 29 X-Country Run 1.45
 Burnt Oak 2.00 Greenford 2.00

PM in Emmanuel Hall Committee Room, 7.15 - 7.30 Fridays

Senior Programme NORTHWOOD COVENANTERS November 1974

	somewhere else	in church	in private	(underline)
SUN 3 MAIN MEETING 3.50				When ?aseow
Tue Swimming		7.00		11 Christmas Dance 2.00
Wed The Kings				(underline)
Fri 8 Games Evening 7.30				SUN MAIN MEETING 3.50
SUN 10 Breakfast 8.00			Tue 26	Swimming 3.11.75 00
MAIN MEETING 3.30			Fri 29	GAMES EVENING 8.30
Tue 12 Games Evening 8.00				WITH PARENTS 9.30
Thu 14 Swimming 7.00				X-Country Run 1.30
Sat 16				South Ruislip 2.00
SUN 17 MAIN MEETING 3.50				MAIN MEETING 3.50
Mon 18 Swimming				7.00
Wed 20 "Judgment" 8.15				"The Return" 8.15
Fri 22 Games Evening 7.30				Games Evening 7.30
TT v N Harrow 7.30				Sat Sailing 9.30

Just to let you know that our Work Day brought in a total of £1,100 for the news. We have asked £220 which we were able to send. Market Stall will go towards... folk around others is our area...

PLEASE...

Well done!

Found by Fabian Monheim,
Flea Market Typos, 1995
After finding these student card
misprints and typos at a flea market
in 1995, Fabian Monheim has since
used them as the basis for a series of
postcards and has plans to use them
to design a forthcoming range of
wrapping paper.

Dear Sharon B

Stuart Bailey, Fax Book, 2000
Having kept faxes sent to him, Bailey
compiled a selection of these faxes
and randomly put them together
in the form of a book. This chance
juxtaposition transforms the limitations
of 'the fax' into a new kind of visual
experience. The faxes cease being
faxes and instead merge into often
surprisingly beautiful compositions.

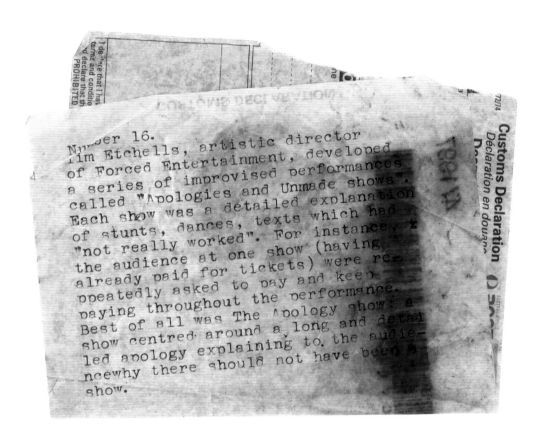

Number 16.
Tim Etchells, artistic director of Forced Entertainment, developed a series of improvised performances called "Apologies and Unmade shows". Each show was a detailed explanation of stunts, dances, texts which had "not really worked". For instance, the audience at one show (having already paid for tickets) were repeatedly asked to pay and keep paying throughout the performance. Best of all was The Apology show: a show centred around a long and detailed apology explaining to the audience why there should not have been a show.

Concept: Nick Bell, designer: Chris Arnold, Draft Worldwide, National Asthma Campaign poster, 1994
For this National Asthma Campaign poster, a sign-writer coated the posters with waterproof glue, carefully masking off the lettering. When first put up, the posters were blank. 'But after a week,' Bell recalls, 'airborne particles started to adhere.' After a fortnight, the message on the poster became visible, the copy driving home the concept, 'This poster has been up for just two weeks. Imagine what your lungs must look like.'

GRAPHIC DESIGN

SENIOR SHOW, MARCH 7, 6-7:30PM WOODS GERRY

745.444 MAN
Man Transforms: An International Exhibition
on Aspects of Design
Hollein, Hans/Nelson, George
NY: Cooper-Hewitt Museum, 1976
p 70/71
**index card – handwritten text and stamped date:
'05 Jul 1999, Machine Aided Art, Machine Related Art,
Machine Free Art, Machine Made Art, Mechanical Art,
Perpetual Art, Reproducable (sic) Art'**

745.44952 HIB
Japanese Detail: Traditional Table and Kitchen Ware
Hibi, Sadao
London: Thames & Hudson, 1989
p 126/127
b/w photocopy of a fish

745.51 SPE
The Art of the Woodgraining
Spencer, Stuart
London: Macdonald & Co Ltd, 1989
p 102/103
floor lino scrap – wood effect

745.542 DEV
English Paper Mâché of the Georgian and Victorian Periods
DeVoe, Shirley Spaulding
Middletown, Connecticut: Wesleyan University Press, 1971
p 10/11
adult single bus ticket, route 220 – 19/01/01, 70p

745.66 FOX
The Art of Heraldry: An Encyclopedia of Armory
Fox-Davies, Arthur Charles
London: Bloomsbury Books, 1986
p 232/233
RCA compliments slip – handwritten text, book references

746.1408998 ADE
Aymara Weaving: Ceremonial Textiles
of the Colonial and 19th Century Bolivia
Andelson, Laurie/Tracht, Arthur
Washington: Smithsonian Institution Travelling
Exhibition Service, 1983
p 2/3
A4 b/w photocopy – printed text, yarn ordering request form

746.3 BLU
Creative Design in Wall Hangings: Weaving Patterns
Based on Primitive and Medieval Art
Blumenau, Lili
London: George Allen & Unwin Ltd, 1968
p 28/29
books in use card – printed/handwritten text

749.22 AGI
British Furniture 1880-1915
Agius, Pauline
Woodbridge: Antique Collectors' Club, 1978
p 132/133
notepad leaf – drawing of a face in black ink

779.0924 NAC
Deeds of War
Nachtwey, James
New York: Thames and Hudson Ltd, 1989
p 14/15
scrap piece of paper

05 JUL 1999

MACHINE AIDED ART
MACHINE RELATED ART
MACHINE FREE ART
MACHINE MADE ART
MECHANICAL ART
PERPETUAL ART
REPRODUCABLE ART

704 IMA
The Image of the Black in Western Art 2:
From the Early Christian Era to the Age of Discovery
Devisse, Jean
New York: Office du Livre, 1979
p 88/89
**torn lined paper – handwritten text:
'photocopy 45-47, 46'**

704.942 GAB
The Pin-Up: A Modest Histor...

AMERICAN INDIAN SYMBOLS
AND THEIR MEANINGS
The earliest writings of the American Indians were in
of signs and symbols. These symbols are always combin
in their handicraft and jewelry.

Hi Maria,
How are things
in London? I'm sure
it feels good to be
home. What did you
do in Mexico? Please
write! I'm in the
process of moving – it's
hell!! Here's my address
in Seattle →

Maria Cook
26B Alkham Rd.
Stoke newington,
LONDON
N16 7AA

Mary Condon
4736 1/2 University Way
Apt. C,
Seattle, Wa. 98105

**paper scrap – printed text:
'Calderdale Libraries. This book has been lent through
the courtesy of another library, and every care should be
taken to ensure its return on or before 8/10/77. If you wish
to retain the book for a longer period, please inform the
Calderdale library which issued the book at least three
days in advance of this date'**

704.9482 HUG
Heaven and Hell in Western Art
Hughes, Robert
London: Weidenfeld & Nicolson, 1968
p 160/161
**pink quicklet post-it note – illegible handwritten text:
'Dissertation-5000 wds. Thursday-Sunday First draft
complete. Monday-Type out & make... at college. Get
quotes and images. Phone Lib about Eccentric spaces'**

708.3 ULM
Graphik Von 1890 bis Heute Katalog
Ulmer Museum
ULM Museum der Stadt Ulm, 1964
front page
Boomerang Media St George's Day postcard

708.5 UFF
The Uffizi
Berti, Luciano
Firenze: Becocci, 1971
front page
pink post-it note – handwritten text

709 HAU
The Social History of Art Volume 2
Hauser, Arnold
London: Routledge and K Paul, 1951
p 664/665
**postcard dated 26/05/93, illustration of American
Indian Symbols and their meanings – handwritten text:
'Maria Cook, 26b Alkham Rd, Stoke Newington, London,
N16 7AA. Hi Maria, How are things in London? I'm sure it
feels good to be home. What did you do in Mexico? Please
write! I'm in the process of moving-its hell! Here's my
address in Seattle, Mary Condon, 4736 1/2 University Way,
Apt C, Seattle, Wa. 98105'**

709.01 CHR
Primitive Art
Christensen, Erwin O
New York: Bonanza Books, 1955
back page
note paper – handwritten text

Previous pages
**Isaac Tobin, Graphic Design Senior
Show poster, 2002**
To announce the Senior Show at
Rhode Island School of Design,
Tobin (then a student), designed this
poster using found cardboard boxes.
He says he's drawn to using collage
because it 'creates imperfect yet
harmonious compositions that are
made up of fragmented references
to whole objects'.

Left
**Sophie Beard and Allyson Waller,
The Readers Before Us, 2002**
While studying at the Royal College
of Art in London, Beard and Waller
collected ephemera found between the
pages of books inside the RCA library.
These 'memories' serve as proof, or
evidence, that 'the act of reading
creates its own imprint', leaving traces
of 'the readers before us'.

Caterpillar Tractor Co.

Humid Plain

Aaron —
I really can't see the humor
in explaining to my professor why
my homework has pornography taped to
it, or having parts of an equation ripped
out of my book because of taped man porn.
Please make sure that those kinds of things stop. :

Beer. Meat.
Dog Food
boloney
Bread
Sanka

Opposite page

**Jason Otero and Rick Griffith,
MATTER, *Dry Plain* poster, 2001**

With some help from the printmaking
and letterpress shop in their design
studio, MATTER silk-screened retro-
graphics onto a found map to provoke
and arrive at this random composition.

This page

Ticket for Funny Story found by
Jordan Morris in 1999, *Can't See
the Humour* found by John Kovacs in
2000, *No Water* found by Rachel Burns
in 2001. Courtesy of *FOUND* magazine.

**Davy Rothbart of *FOUND* magazine on
*Random Discoveries***

'Late one snowy night in Chicago I left
my friend's apartment and went out
to my car. On the windshield I found a
note intended for someone else, a guy
named Mario. The note said, "Mario,
I fucking hate you. You said you had
to work, then why's your car HERE, at
HER place?? You're a fucking LIAR. I
hate you, I fucking hate you. Amber.
PS Page me later."

'Since grade school I'd been collecting
notes, letters, photographs, and other
stuff I'd found on the ground. When
I discovered Amber's note to Mario,
I was so moved by its blend of anger
and longing that I had an idea – why
not create a magazine and publish
Amber's note, along with the rest of
the incredible finds my friends and
I had turned up over the years?

'As I travelled around the country over
the next few months, I passed
out flyers inviting folks to send in
stuff they'd found. Notes came in from
as far away as Alaska and Bangladesh.

'Once I'd gathered a decent stack of
material, a couple of friends and I
went to work cutting and pasting with
scissors and tape and put together the
first issue of *FOUND* magazine which
contains a wide range of found items:
letters, shopping lists, resumés, kids'
homework, short stories written by
inmates at a prison in Michigan and
a woman's diary from her vacation
to Hawaii.

'Found notes and letters open up the
entire range of human experience;
they offer a shortcut directly into
people's minds and hearts. I think
that's because when we read these
notes, there's often a powerful
moment of recognition; we see
another person – maybe someone
very different from us – experiencing
the same thoughts and feelings and
emotions that we've experienced. It's
startling and it's magical. Suddenly
we feel connected to this person
we've never met before and likely
never will.'

Davy Rothbart, point guard, *FOUND*
magazine, www.foundmagazine.com

Darrell Gibbs, Sukie,
Rescued paper notebooks, 1999
Sukie's one-of-a-kind rescued
paper notebooks are, in the words
of Darrell Gibbs, 'handmade
from 100 per cent discarded paper
which we collect, sort, bind, trim and
package.' The notebook shown here
(spread shown above, cover right)
is made up of discarded, used and
found envelopes.

rescued paper note book made from **used envelopes**

36. For its Berlin issue, shift!, an independent magazine, invited ten people who didn't know each other - from different creative disciplines, from different parts of Europe- to spend a continuous, uninterrupted week together, during which they were expected to create the issue.

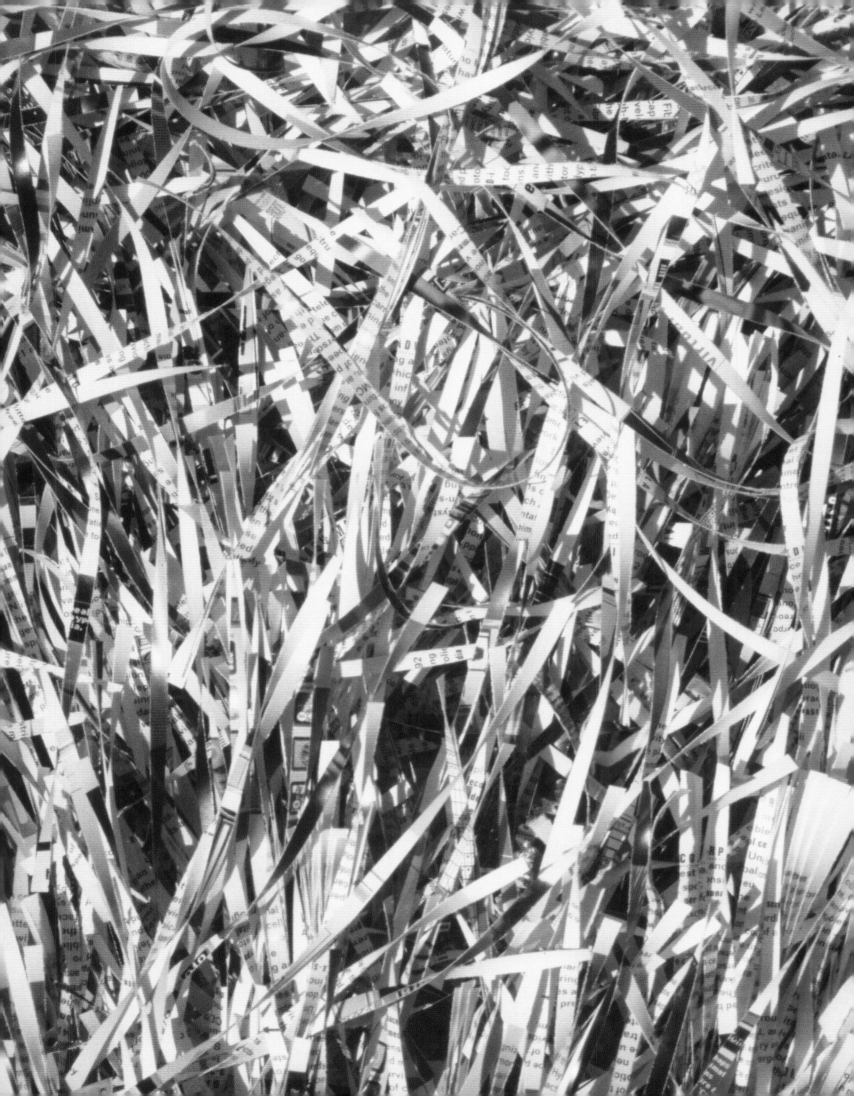

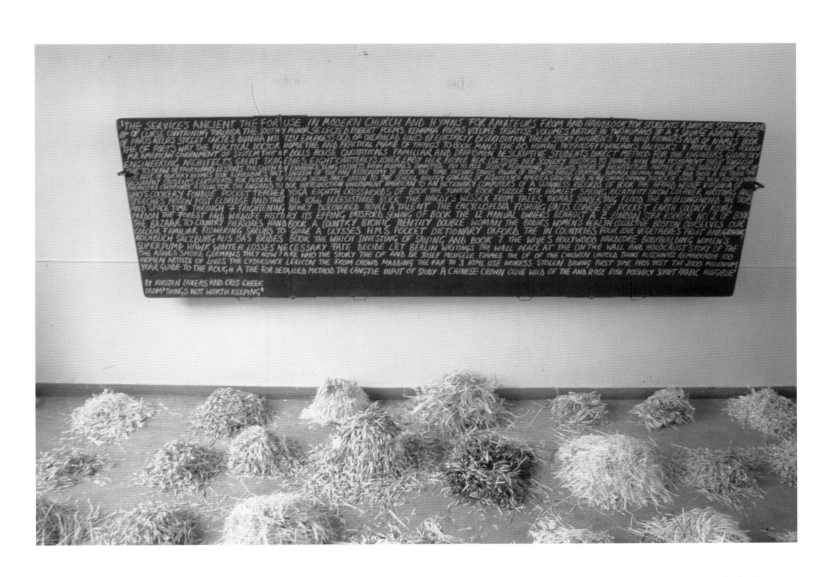

Kirsten Lavers and cris cheek,
Things Not Worth Keeping,
shre(a)d(d)ing title, **1999**
shre(a)d(d)ing title was part of an installation for 'In the Event of the Text: Ephemeralities of Writing' in Holland. 101 books, that Lavers and cheek had removed from their personal library and deemed 'not worth keeping' were shredded. Reduced to debris, the 101 books wound up as 'ten bags and one jar of bookdust'.

35. Launched in 2000, The Library of Unpublished Books is a collection of abandoned novels, private diaries, unread autobiographies and manuscripts rejected by publishers. To seek out new submissions, the librarian goes to unplanned destinations where she leaves notices calling for submissions, ensuring that the collection stays spontaneous. The library creates a space for neglected writing, writing that would otherwise remain unread.

This page

Paul Ayre, European Music Awards, MTV, 1997

To achieve the effect he wanted, Paul Ayre applied a 'combination of Lemon Flash floor cleaner, cooking oil, sparkling water, Alka-Seltzer and various food dyes' onto the film for EMA MTV motion graphics. A local hospital supplied Ayre with a bin bag full of X-rays, which he 'just placed under a rostrum camera' in order to produce 'a random stop-frame animation' that was conceived, created and executed with 'no predetermined reason or method'.

Opposite page

Marcus Walters, New Future People, Photo journal, 2001

When Marcus Walters started his travels around New Zealand, Australia and Japan, he arrived with a broken camera. Instead of buying a new one, Walters ended up buying four different plastic cameras. After months of travelling, when he got his films back, he says that 'each camera had its own characteristic, or fault. One of them takes only shaky and blurred photos, one leaks light or under exposes and another doesn't wind properly.'

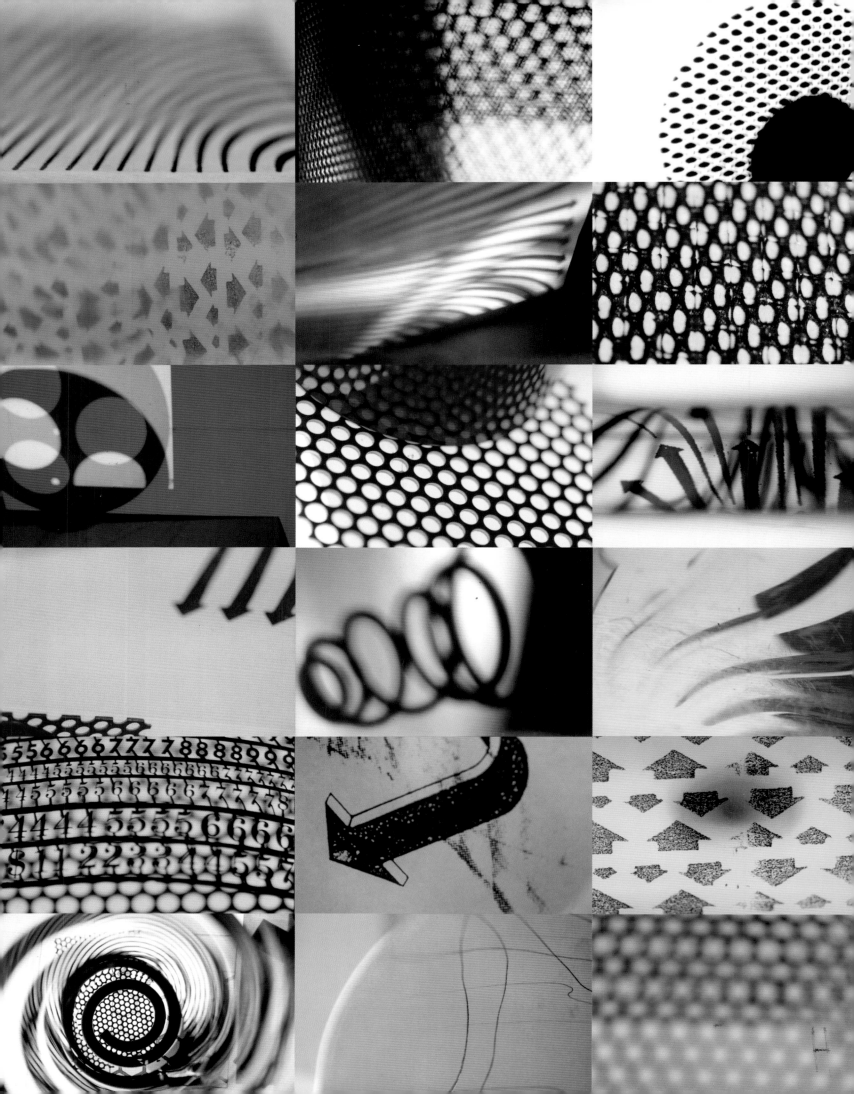

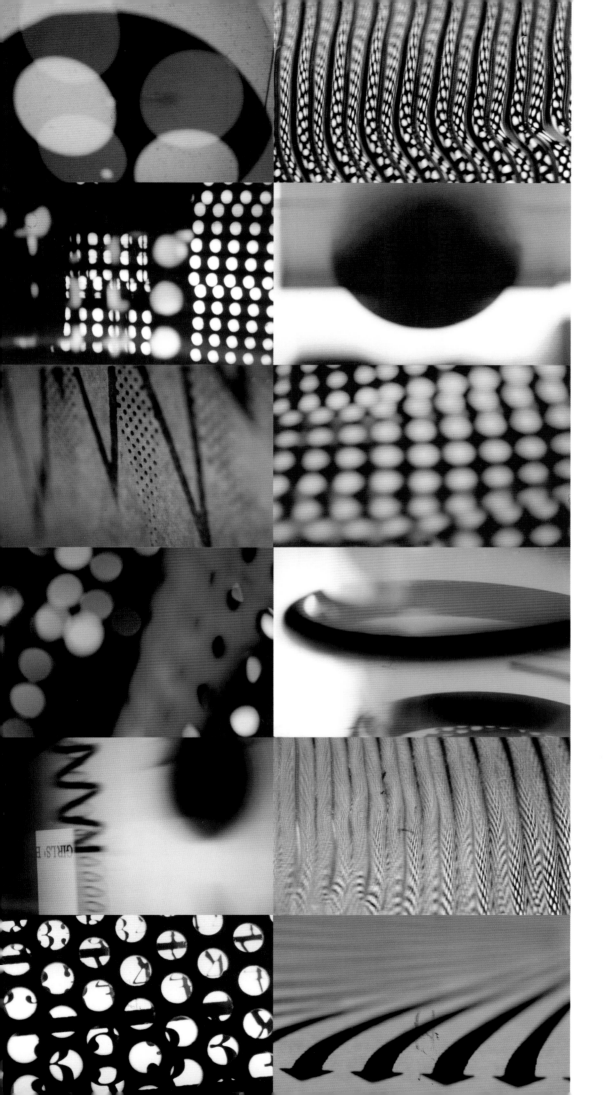

**Martin Venezky, Geoff Kaplan and
Scott Oliver, Appetite Engineers,
Reebok Trade Exhibit, 1997**
'The Reebok photo shoot was
intentionally arranged to avoid
predetermination,' Martin Venezky
remembers. 'Each of the participants
brought in a variety of material,
slides, light sources and cameras.
We created a "three-ring circus"
atmosphere, with several set-ups
going on at once, whose light and
shadows often intersected with each
other. All of this was going on for
several hours and we all wandered
through the sets snapping pictures.'

111

Above
do foundation, Marijn van der Poll,
***do hit*, 2000; Frank Tjepkema and**
Peter van der Jagt, *do break*, 2000;
illustrations by Stang Gubbels
do break and *do hit* are part of the *do create* series, a collection of products which invite the consumer to interact with the work to ensure that the end product is 'beyond the control of the designer'. *do hit* is described as 'hit, smash and bash this metal cube to your heart's content and sculpt for yourself the shape you want it to be'. *do break* is described as, 'a porcelain vase which, because of its rubber casing, doesn't fall apart when you attempt to break it'.

Left
William van Roden, good will design,
***Blue Glitch*, 2002**
Blue Glitch is one of many 'scan glitches' that good will design have made a point of collecting since their inception. 'Basically, my cheap Epson scanner will scan something though I may have the settings incorrectly set', explains William van Roden of these fortuitous accidents. 'Sometimes, when this happens a wonderful glitching of lines and colours happens.'

Artifact + Allegory

The artifacts of cybernetic culture relay their fragmentary messages along the surfaces of the city; the message of the fragment in late capitalism always being the totality itself and the world system. These are texts that may be read, broken alphabets that trace out the contours of immaterial circuits and flows.

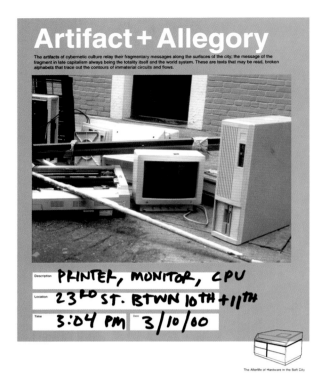

Description **PRINTER, MONITOR, CPU**
Location **23ᴿᴰ ST. BTWN 10ᵀᴴ + 11ᵀᴴ**
Time **3:04 PM** Date **3/10/00**

The Afterlife of Hardware in the Soft City

Fetish + Fossil

The image of the fossil captures that process of natural decay that marks the survival of past history within the present, expressing with a palpable clarity what the discarded commodity fetish inevitably becomes, so hollowed out of life that only the imprint of the material shell remains.

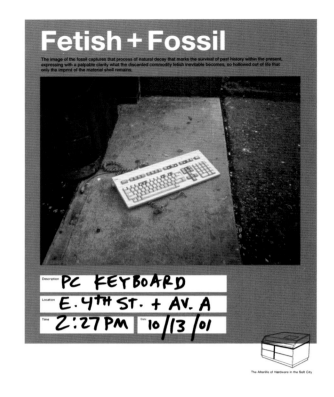

Description **PC KEYBOARD**
Location **E. 4ᵀᴴ ST. + AV. A**
Time **2:27 PM** Date **10/13/01**

The Afterlife of Hardware in the Soft City

Relic + Ruin

The technological debris of postindustrial culture teaches us not the necessity of submitting to historical catastrophe, but the fragility of the social order that tells us this catastrophe is necessary. The crumbling of the monuments that are built to signify the immortality of civilization become proof, rather, of its transiency.

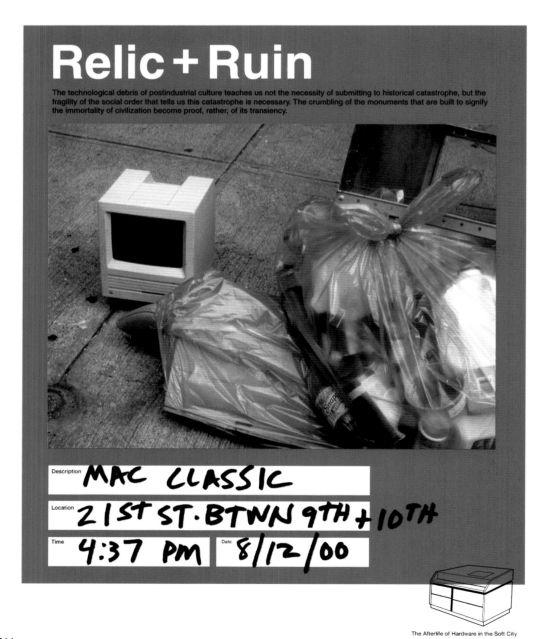

Description **MAC CLASSIC**
Location **21 ST ST. BTWN 9ᵀᴴ + 10ᵀᴴ**
Time **4:37 PM** Date **8/12/00**

The Afterlife of Hardware in the Soft City

This page
Mark Owens, Life of the Mind,
Soft City, **begun 1999 (ongoing)**
Mark Owens started working on his ongoing computer junkyard ephemera project, 'The Afterlife of Hardware in the Soft City', while still a student at Yale University in the 1990s. As he explains, the project 'involves cataloguing various randomly discovered bits of discarded hardware on the streets of New York'.

Opposite page
Mark Diaper, Eggers + Diaper,
Waste, **2001**
Waste is a journal made from and determined by what's left of trimmed printer's sheets (i.e. the margins). As Eggers + Diaper explain, '*Waste* is by definition subject to random influences. We have to go with whatever format, colours and paper are available to us. These will change from article to article, with the result that no two issues will resemble each other.'

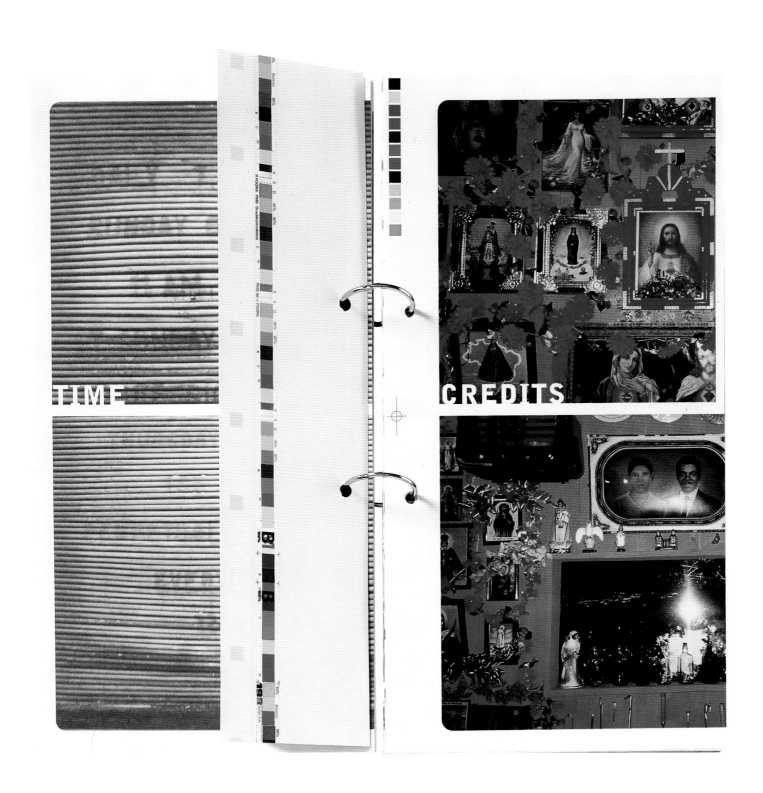

TIME

CREDITS

THAN

from**misskarenjane**@hotmail.co

Designer: Libby Brockhoff; copywriter: Mark Waites; creative directors: Libby Brockhoff and Mark Waites, *Random Magazine*, **1997**

Mark Waites and Libby Brockhoff cut up an already published copy of *The Face* and randomly generated the hacked up sections into a new radically re-configured version of the magazine. On account of the now plentiful possibilities and variations by which *The Face* could be 'read', they called the end-product *Random Magazine*.

Karen Jane Robins,
Recycled Logo, **2002**
After finding a discarded Burger
King carton in the street, Karen
Jane Robbins tore out the 'K' in
the Burger King logo and used it to
make a dye-cut 'K' shaped hole. She
then reappropriated the result as her
own logo. 'The resulting shape', she
explains, 'looking something like a
map of Poland with a "K" in the centre
inspired me through the randomness
of its creation to use it for my logo
and to have it tattooed on my back.'
~~"looking something like a map of
Poland with a 'K' in the centre inspired
me through the randomness of its
creation to use it for my logo and to
have it tattooed on my back."~~

THE AUTHOR

Stephen Bayley was born in Cardiff in 1951 and educated at Manchester University and Liverpool School of Architecture. In the 1970s he was a lecturer in history of art at The Open University and the University of Kent. In the eighties he created the influential Boilerhouse Project at the Victoria & Albert Museum, London, and later became Director of the Design Museum. One Boilerhouse exhibition, on Coca-Cola's brand image, was among the most successful exhibitions ever held in London. Since 1990 Stephen Bayley has been a design consultant advising Ford, Coca-Cola and controversially the Labour Government. In 1989 he was made a Chevalier de l'Ordre des Arts et des Lettres by the French Minister of Culture.

His books include *In Good Shape* (1979), *The Albert Memorial* (1981), *Harley Earl and the Dream Machine* (1983), *The Conran Directory of Design* (1985), *Sex, Drink and Fast Cars* (1986), *Commerce and Culture* (1989), *Taste* (1991), *Labour Camp* (1998) and *Moving Objects* (1999).

He has lectured throughout Europe, the United States, Japan and Australia.

'We have dear Dr Freud to thank for Stephen Bayley, a witty British writer ... who believes that virtually everything to do with automobiles can be traced to sex.'

: JONATHAN YARDLEY on *Sex, Drink and Fast Cars* in *The Washington Post*

'Eloquent fury ... wit and precision.'

: ROWAN MOORE on *Labour Camp* in the *Evening Standard*

'A model of its kind ... a flowing narrative style incorporating wit and individuality.'

: JUDITH TOMLIN on *The Albert Memorial* in *Architectural Association Review*

'A streamlined journey into a special region of the American Dream.'

: ROBERT JOHNSON on *Harley Earl and the Dream Machine* in *San Diego Magazine*

'He sat down at a corner table in the Daddy's Sauce canteen, forced a ballpoint between his unwilling fingers, spat on its tip and never looked back.'

: JONATHAN MEADES

'Stephen has been extruding wisdom on design since well before it became unfashionable.'

: CARL MAGNUSSON

'Stephen Bayley has nailed down the elusive word 'taste' with wit, wisdom and a great deal of fascinating information.'

: DOMINICK DUNNE on *Taste*

'In debunking the phenomenon of taste through the ages, Bayley has opened up the subject more expansively than any writer I know. He has nosed out vulgarity in the most surprising and sacrosanct places and analyzes its anomalies deftly and sometimes uncannily. Social history at its sharpest.'

: JOHN RICHARDSON on *Taste*

'A rattling good yarn of high profits and low cunning ... all the PhDs who will follow in his wake will have to begin their own bibliographies with the words "Stephen Bayley, whose pioneering study...".'

: REYNER BANHAM on *Harley Earl and the Dream Machine* in *New Society*

'Stephen Bayley is the truest chronicler and shrewdest observer of those matters by which we remember our times.'

: MATTHEW FORT

ISBN 1-86 154-068-X

Booth-Clibborn Editions
12 Percy Street, London W1P 9FB
www.booth-clibborn.com

DESIGN/MEDIA/POPULAR CULTURE

3 IN AUGUST 1993, THE MUSEUM OF SCIENCE AND ENGINEERING IN NEWCASTLE HOSTED 'THE MUSEUM OF ACCIDENTS'. AN EVENT BY ARTIST LOUISE WILSON (OF THE WILSON SISTERS). A LARGE PROJECTION SCREEN HUNG ABOVE THE AUDIENCE SHOWED 2 PLANES FLYING TOWARDS EACH OTHER. TEASED BY THE PROMISE OF A VIRTUAL AIRPLANE CRASH, THE AUDIENCE WERE LEFT WITH THE EERINESS OF AN ACCIDENT THAT NEVER HAPPENED.

STEPHEN BAYLEY

/GENERAL KNOW-LEDGE

GENERAL KNOWLEDGE

General Knowledge is a collection of Stephen Bayley's writings produced during a twenty-year career that has seen him propelled from the obscurity of academe to the front line of the worldwide design debate. His Boilerhouse Project at the Victoria & Albert Museum, London, became London's most successful gallery of the eighties and the Design Museum that evolved from it remains unique.

Recognized for his unique role as style guru, he is also known for his searingly independent, perceptive, controversial, rigorous and witty journalism, which covers taste and design in the broadest sense, embracing popular culture, cars, art and society.

This book groups early academic pieces, essays from exhibition catalogues and book extracts with Bayley's better known, irreverent journalism to reveal the evolving character of design as it moved from professional concern to the very centre of popular and high culture.

Bayley was one of the first to define the cult object. Designed as a pleasure to read, with stunning typography by graphic design group GTF, *General Knowledge* is destined to become a cult object in its own right.

Graphic Thought Facility, *General Knowledge*, 2000
'The typeface was drawn by a friend, Julian Morey, of the Club 21 Foundry', GTF explain of the cover for Stephen Bayley's *General Knowledge*. 'It is based on the crude headline lettering that appeared on WH Smith's magazine and newspaper bundle delivery notes.' Courier, the other typeface used, along with the other 'graphic furniture' were also inspired by Morey's collection of found delivery notes.

Liverpool Street station 4.04 pm

 girl in pink jom n blue bike bmx
whimt oacarriermteseo holding hands scarf crenm reebok
brief case brown paper reading paper
large lady indigo ruck sack red coat like mine
nice b lue shirt man orange guard
pissed man asking for twenty pence
little boy looking right at me black bommer
bright rr3ed hat
shoulder bag
red puffa
peach older under arm
whsmith green hammels girl blonde a ll in one red red
tie pink carrier black coat long
family holding hands strange looks man with glasses
smooth essex boy in leather black jacket and ck shoes
blue and red puffas
guards golf umbreela wheely siuitcase

 cute kid with chocolate all over his f ce
 bloke wandering aimlessly with mobile
f nike cortez, 2
 kids, 2 scaring away pigeon by roaring
funny pigeon strutting like catwalk model
bloke with big boy , ki s playin long way away
alarm bell ringing
blonde with big leather boots little girl looking silly d
bloke folds newspaper under arm like a rifle
ir max 95s
platform 95s man looking at me, b by girl pushing toy p m
reebok classics, boy with east 7 arctic camo trousers
lots of people staring up at board look like they re goin to faial over
old west indian lady in big pink jacket
someone, little boy drinking milkshake staring me
in laught kid with big hair and cuts all over her face looks sad
bright green didas jacket toke ne ington.
louis vuiton bag. mor ir m x 95s
old lady gorping into thin i . big greyhound licking it lips
wheely suitcase security gurd walking bout up t irs look laughing at me
spotty scarf on woman m n buying newspaper woman look bored
din announcement c nt h r it
man running for train in it twenty five
brand new white and black cortez bit of fluff
tie rick man with big glasses whistles
two sisters with matching purple coats.
bound at of two
coughing. ponce ith long hair nd cool sungl ses. upper crust
 girl with pink coat with older woman looking at the tr in times
woman girl with long blue coat woman and blue trousers with yellow adidas tw trainers
 littlie boy with folk for onge and green hat
 group of 4 people one with light blue bag
 man with red bag combat trosers red
 yellow 2 men one saying good bye
 and blue jacket
 greeen suitcase
brown bag push chair woman with white coat with beard man on mobile with briefcase
 woman with white coat
 big woman in wheel chair gipattking louds about work
 woman in wheel chair
 2 woman one thin
 guy with trollie ccleaner
 cleaner trolley man buying ticket looking at what i am doing

 man looking at ticket bouchine woman trying to find something in her bag
 t ll man whistling
 next bag man with tool kit at the ticket ma
man looking at board carrier posh poncho lady
man looking at bord running pushed ginger hair carrot little playing with his fin
playing with his fingers navy playing with tie holding ha nds

wheel chair little ginger boy looking vv curte coy
wink beep beep luggage caerrier addidas red co t lilac bag
cream jacket fast walking delays cross legs kwik save bag waiting
high pitched voice lying on floor blue paper folder
orange bag big green rucksac man in blue marroon pin strip
purple puffa gray suit beige leather poash brief case
two carriers gold buckle dessert boots lots of black suits
nfosters alcho smell wooly big fur collar
marroon case leather hai ir in a bun denim jacket floewer carpet bag
limp girl rugsack on man
base ball cap falfkat cap on lovely old man ckhecked shirt builder dirty
jd sports posh shoes yelllow carrier burgandy coat uniform check faded tartan
coat hippy big wooly hat smart primark burgandy ma c orange macs puffa
lots of red wheel cahhair illumin coat tan leather ke

Previous page, left
Michael Worthington, Letraset, 2002
'The design and position was determined
by whatever had been left on the sheet
over the years,' Michael Worthington
recalls of this beaten up Letraset sheet
which served as the starting point when
he was working on a series of posters.
'As the type masses, putting down
letters began to also take away parts
of the underlying typographic surface.'

Previous page, right
John Sarsfield, Typed Scripts, 2000
Drawing inspiration from the ephemera
of everyday life, Sarsfield travelled
around London, spontaneously
documenting sporadic snippets of
conversation on a portable typewriter.
The script shown here charts randomly
heard extracts of conversation at
Liverpool Street Station.

This page
**Martin Andersen, Andersen M Studio,
Entanglement, John Wiley and Sons
Ltd, 2002**
For this book sleeve, Andersen wanted
to come up with an image that best
reflected the theory of entanglement,
a law of physics which hypothesizes
that all particles are linked together.
'We decided to shoot the title onto
a clear film,' he says of the process.
'We then rolled the clear film, and
shot chance configurations.'

Opposite page
**Nancy Skolos and Thomas Wedell,
RISD Faculty Biennial poster, 2001**
'In 1992 we were invited to give a
workshop at Yale to demonstrate
methods of creating dynamic
compositions,' recall Skolos and
Wedell of the genesis of this poster.
'We tried to think of a way to make
a serendipitous process happen and
came up with the idea of cutting our
old *Domus* magazines into pieces to
use to generate random compositions.'

Rhode Island School of Design
Museum of Art

September 28

October 28

2001

E
EX:, X . XX , XX , , ...
∪ EX

U
EX: ...: X X . (XX) X X , XX...
∪ EX

MX X X
EX: ...-X, - XX , XXX , ...
∪ EX

FX
EX: ... (XXX) . (XX) XX , , ...
∪ EX

CX X X
EX:, X , X , X XX , XXX X , ...
∪ EX

NX X
EX: X X X XX XX I XX X...
∪ EX

Error
Excerpt: "..., misreport; mumpsimus. mistake;
miss, fault, blunder, quiproquo..."
[View Entry]

Unskillfulness
Excerpt: "...: too many cooks. blunder (mistake);
etourderie gaucherie, act..."
[View Entry]

Misinterpretation
Excerpt: "...-reading, cross-purposes; mistake.
misrepresentation, perversion..."
[View Entry]

Failure
Excerpt: "...î (disappointment) . blunder (mistake);
fault, omission, miss..."
[View Entry]

Certainty
Excerpt: "..., no doubt, doubtless, and no mistake,
flagrante delicto, sure..."
[View Entry]

Negation
Excerpt: ".... there never was a greater mistake;
I know better; non haec..."
[View Entry]

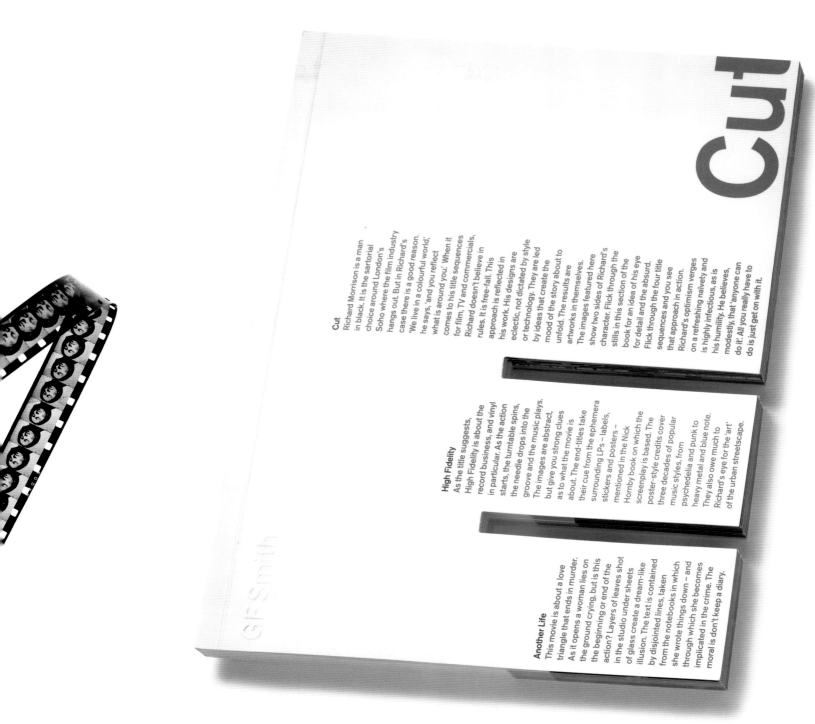

Cut

Richard Morrison is a man in black. It is the sartorial choice around London's Soho where the film industry hangs out. But in Richard's case there is a good reason. 'We live in a colourful world,' he says, 'and you reflect what is around you.' When it comes to his title sequences for film, TV and commercials, Richard doesn't believe in rules. It is free-fall. This approach is reflected in his work. His designs are eclectic, not dictated by style or technology. They are led by ideas that create the mood of the story about to unfold. The results are artworks in themselves. The images featured here show two sides of Richard's character. Flick through the stills in this section of the book for an idea of his eye for detail and the absurd. Flick through the four title sequences and you see Richard's optimism verges on a refreshing naivety and his humility. He believes, modestly, that 'anyone can do it'. All you really have to do is just get on with it.

High Fidelity

As the title suggests, High Fidelity is about the record business, and vinyl in particular. As the action starts, the turntable spins, the needle drops into the groove and the music plays. The images are abstract, but give you strong clues as to what the movie is about. The end-titles take their cue from the ephemera surrounding LPs – labels, stickers and posters – mentioned in the Nick Hornby book on which the screenplay is based. The poster-style credits cover three decades of popular music styles, from psychedelia and punk to heavy metal and blue note. They also owe much to Richard's eye for the 'art' of the urban streetscape.

Another Life

This movie is about a love triangle that ends in murder. As it opens a woman lies on the ground crying, but is this action? Layers of leaves shot in the studio under sheets of glass create a dream-like illusion. The text is contained by disjointed lines, taken from the notebooks in which she wrote things down – and through which she becomes implicated in the crime. The moral is don't keep a diary.

Opposite page
Giles Dunn, Punkt, Inside cover of CD for Ryuichi Sakamoto, 1999
To arrive at this image, which graces an album by Ryuichi Sakamoto, Giles Dunn threw, quite literally, a spool of Super-8mm film onto a light box and photographed the results. A perfect example of chance and process fusing to create a beautiful composition.

This page
Atelier Works, Cut Book, 2002
For this paper company brochure, Atelier Works transformed Richard Morrison's vast collection of photographs into a kind of 'flip book' by cutting up the book. 'Rather than spend days trying to achieve the right visual affect with each combination of pictures, we left it entirely to the repro house which order the photographs appear in.'

his arms and legs about until, to cap the climax, he tumbled
out of bed, bumped his head a resound... ick, and
the who... ehold fr... und sle... r long h
such ov... ion, his... lungs w... ly to bu
next day... him, wea... miserable, achin... ry joint.

Sto **f a** **Boy**

week's... he put... ks asid... physical
he thoug... even thi... ance to... p hope,
was cu... de him... late. H

believing... would... healthy... be able t
and wre... h his p... s able t
the happ... at come... turdy, c... youth.

here live... ny Ind... e city o... a thin
and sick... d intere... me und... icative... had had... ised the
every m... ning les... ease—sc... nth birt... rit. But
and the... ontagio... d readin... er, dyse... ings of... yphus... in the... satisfy
serious little sho... more n... ses so c... at deal... o probl... He sur-
On a... deed, bu... miracle... on was... was still... as only
and sun... l bones... utumn... t a dep... he ran... conditio... ollowed
never w... atha Y... le face... nd flat... ked, his... t this li... he long-
ogi wa... chest n... rary, h... p of yo... was a... ble who
vsician... er! nded b... rn the si... ed in a... the yo... in the
remained... his tea... ing, wa... the sv... uring t... gentlest... a dista... g shady
saw tha... Neverth... ung me... house... he grou... ras, wit... with... fliction
and tha... were p... beautiful... nt worr... g stran... ses. He
were th... ced that... of its i... re glow... nts; for... health. losely t... e group
and coo... p, the... tle child... r appr... d more... the ma... shadow... asked
boy... ccept n... pupil.
Two... ather tri... ater the... mean... s docto... n to me... recogn... But he
son. No... ucceede... y walk... ing his... ht as ar... e. His ch... longer
obliged of a ye... own h... chest h... r hour, nded f... Now he... pas... ay. At
this mo... legs ha... he was... t doubl... live like... broader... ter little... es. His,
his age... lly, he... nted fr... e. From... nastics... he was
the Eng... was sh... nastic... s in the... he had... om ever... aken... art in
terous... e was f... ht! he cau... mona, the ma of air.
When... acle... wenty... d to m... death... The... her, he in, as if
trouble a dista... new. Ha... visit... r later... er to whirly we... are and
but too... parents, the me... healt... ght. With, and... hardly... er God
how... his mast... or... e had... envi... ner cal... itself,

17

'I had been experimenting with placing things out of their original contexts,' Klein says of *Yoga Book*. 'Thinking about the word "context", the Latin root of the word is *contextere* which means to weave. I wove together the pages of a book I had found in a bookstore. This resulted in combinations of words and that idea created new meaning.'

Emma Thomas designed the poster shown for a seminar series called 'Between the Frames' run by Al Rees while studying at the Royal College of Art. 'I designed a simple notice board information poster-stencil,' she says of the work. 'Then one evening I positioned the stencils on the floor at different entrances to the college and sprayed over them with Spray Mount. The posters were invisible until people began coming in and out. They started to appear as the dirt from everybody's shoes built up on the sticky surface.'

number 27.
When titling chapter and section breaks for his book "Essays in Design," J Christopher Jones 'borrowed' from the American poet Wallace Stevens. He created the following chance "system": first, he randomly picked a number. Then he turned to that page number in a collection of poetry by Stevens. Whatever poem this random process led him to, he then lifted its title for his own book.

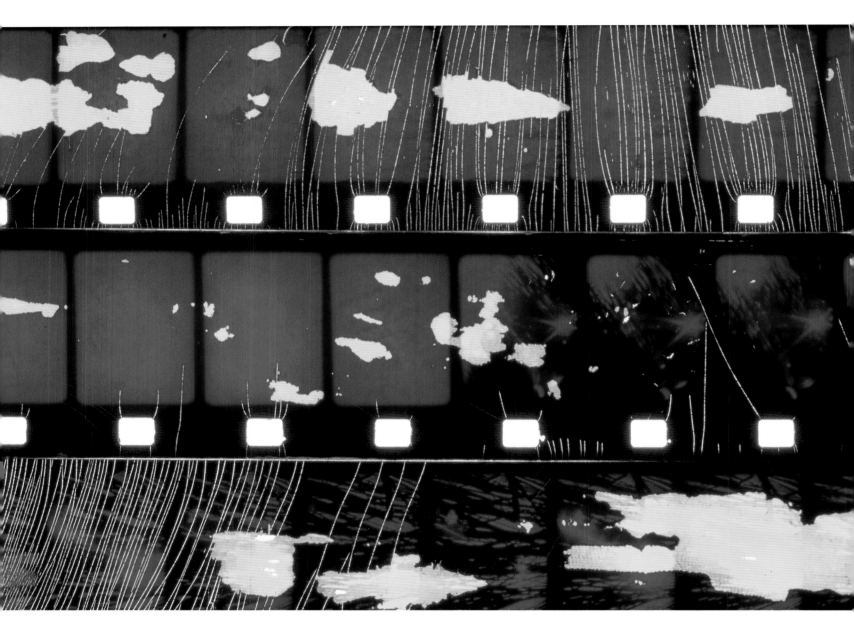

Previous pages
Richard Hennings, Stolenspace,
***Dry*, 2003**
'On and off for about six years, I've
been collecting typographics, textual
rubbings, misprints and discovered
type from various objects such as
manhole covers and cardboard
boxes, all beautiful in their own way.'
Hennings uses his previously designed
typeface 'Itchy Trigger Trigger' (inspired
by cardboard boxes from his growing
archive) for this special commission.

Ken Paul Rosenthal, *Blackbirds*, **1998;**
***Spring Flavor*, 1996**
These 16mm film frames from
Blackbirds (above) and *Spring
Flavor* (opposite) illustrate
Rosenthal's interest in indeterminate
photochemical and organic-based
manipulations, and the unpredictable,
textural detritus such processes
breed. For *Blackbirds*, some of
his alternative methods included:
re-photographing and hand-processing
multiple projections through fifteen
generations, cross-processing colour
film in black and white chemistry, and
violently agitating the processing tank
during development. For *Spring
Flavor*, he buried footage in the earth
until bacteria in the soil ate through
the emulsion and revealed various dye
layers. He also stuffed strips of film
into a mason jar filled with cooked
wild berries, and set it before a
southern-facing window for one year
to effect extreme granularity and
solarized, magenta hues.

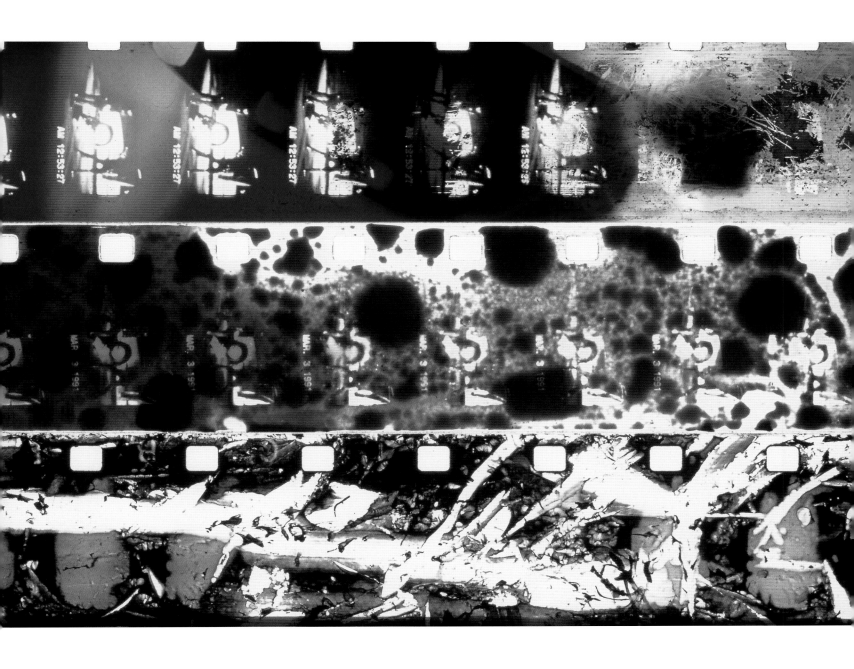

number 42.

in january 2002, dr glazebrook of johns hopkins university, announced
 that the colour of the universe is a shade of turqouise. in march of
the same year, an australian observatory announced that actually the
 universe is beige. the mistake was due to a bug in the software.
glazebrook was quoted as saying, "there's no error in the science,
the error was in the perception."

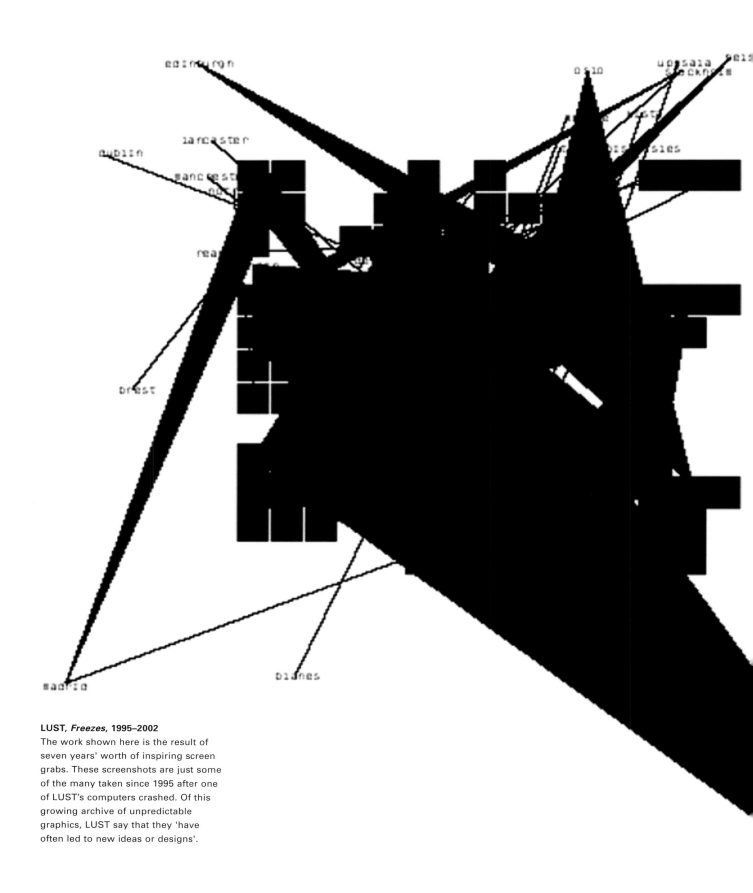

LUST, *Freezes*, 1995–2002
The work shown here is the result of
seven years' worth of inspiring screen
grabs. These screenshots are just some
of the many taken since 1995 after one
of LUST's computers crashed. Of this
growing archive of unpredictable
graphics, LUST say that they 'have
often led to new ideas or designs'.

In 1997-98, American underground rock outfit, The Flaming Lips, staged what they called the 'Human Boom-Box Experiment.' On the stage, they had 40 boom-boxes (with 1 player at each) organised into separate 'orchestras.' where each player was given a bag of 8 pre-recorded cassettes. When synchronised with other boom-boxes, the sound became complete, whole symphonies.

Christie Rixford, SuperNatural Design, *Bone Machine*, Island Records, 1992
When Christie Rixford was developing her ideas for Tom Waits's *Bone Machine* album, the idiosyncratic artist told Rixford that he envisaged the type treatment looking like 'someone wearing glasses had fallen out of a moving vehicle onto the pavement with their face sort of skidding across the road.' Rising to Waits's imagistic challenge, Rixford achieved the desired effect as follows: 'I painted the title and Tom's name on a piece of acetate and then placed it on the bed of the copier, pressed start and began to slide and jostle the acetate back and forth over the light in the copier.'

141

fré|quen|ces|@|pont|saint|esprit

Lu cy Ar ner Re naud Dou cet
De|ni|se Du|pleix Stef ka Ev sta tie va
An|ne Grap|pot|te Ka mal Khan
Lio ra Mau rer Vic tor Di Ren zi
Dia|na So|vie|ro Ber nard U zan
Mal colm Wal ker french art song
french o pe ra ve|ris|mo sum mer
school Pro ven ce Fran ce

Singers program

Those attending fré|quen|ces|@|pont|saint|esprit are serious professional singers and promising students who are working to become professional performers. No music degree is required but a strong musical background is essential.
Master Classes Five public Master Classes (Verismo, French Art Song, French Vocal Technique, How to Audition, Staging and Dramatic Preparation) will be given by major personalities of the opera world.
Performances Singers will be given the opportunity to perform in one or more public recitals: an opening concert, two staged concerts of opera excerpts, a recital of French Art Songs and two staged operas.
Vocal Coachings Students will be able to enjoy private coachings from renowned vocal teachers.
Coachings Individual sessions with special emphasis on musical preparation and style will be offered to the participants by coaches from major opera houses or schools.
Rehearsals Professional stage directors will produce the concerts.
Opera Presentations Renowned professionals from the opera world will introduce six different operas and will also share their personal recollections and experiences while giving advice to singers who are preparing for these particular operas.
This year the repertoire will consist of Madama Butterfly with Diana Soviero, Cavalleria Rusticana with Stefka Evstatieva, La Bohème with Bernard Uzan, Andrea Chenier with maestro DiRenzi, Pelléas et Mélisande with Malcolm Walker, and Manon with Renaud Doucet.
French Language Study Private or group lessons of French conversation, phonetics, diction and literature (in connection with the French Art Song module) will be offered to all interested attendees.
Dance Dance, gesture and movement classes for singers will be given to help improve movement on stage.
Audition Fifteen singers selected by the program's artistic committee will be invited to audition for a group of Directors of Opera Companies, Conductors, Stage Directors and Agents.
NB Singers are welcome to sit on every coaching, staging rehearsal or voice lesson with the approval of the teacher concerned.
Price US$ 3,000 for 4 week courses from 18 June until 15 July 2001. Lodging included (all meals extra).

Coaches program

Five positions of apprentice coaches are open to pianists who want to make a career in the opera field. Candidates will need a strong musical background and a reliable piano technique.
¶They will attend all the Master Classes, Opera Presentations and public recitals.
¶They will play for classes, voice sessions, singer's coaching or staged rehearsals under the supervision of a coach or a rehearsal pianist.
¶They will attend working sessions with a conductor and a professional coach and take part in the concerts or recitals at the discretion of the Artistic Director.
¶They will participate in French and Dance Classes.
Price US$ 2,000 for 4 week courses from 18 June until 15 July 2001. Lodging included (all meals extra).

Auditory program

Non-performing students will be invited to observe all Master Classes, Opera Presentations, Rehearsals and participate in French and Dance Classes. They are invited to all public performances.
This category is opened to singers, voice teachers, coach and conductors who want to observe without involving themselves directly and opera lovers wishing to witness the development of emerging young artists and enjoy the wonderful attractions of Provence.
Price US$ 500 per week, US$ 1,500 per 4 weeks. Lodging and meals are not included.

Information for all applicants

Applications for the singers and coaches program must include the following:
1 US$ 40 non-refundable application fee
2 Resumé (detailing educational experience, opera and recital background)
3 Photograph
4 Two letters of recommendation from established professionals in the opera field
5 A detailed list of their personal repertoire (Opera and Art Song)

For the singers an audition will be held on 10 March 2001, in New York City.

The singers who can not attend the audition will include a videotape with a Verismo aria, a French aria, and a French Art Song with their application dossier.

For more information
Valerie Sorel
fré|quen|ces|@|pont|saint|esprit
10 River Road, Apt. 7M
New York, NY 10044-1446
Tél/F: +1 212 753 5155
Email: frequences@vsorel.com

50% of the fees must be paid on the acceptance of the student by fré|quen|ces|@|pont|saint|esprit. Full payment must be received by 15 May 2001.

Students will be housed with families or in rooms of double occupancy in the music conservatory (supplement for single rooms).

Some of the teachers for the summer 2001

Diana Soviero Singer at the Metropolitan Opera, Paris Opera, Covent Garden; teacher at the Met program and co-Artistic Director of the Florida Grand Opera Young apprentice program.
Stefka Evstatieva Singer at the Metropolitan Opera, La Scala, Vienna State Opera; teacher at the Bethune Cookman College.
Denise Dupleix Former teacher at l'Ecole d'Art Lyrique de l'Opéra de Paris; teacher of Jean Philippe Lafont and Nathalie Dessay.
Anne Grappotte Teacher of French Art Song at the Conservatoire National Supérieur de Musique de Paris.
Victor DiRenzi Conductor & Artistic Director of the Sarasota Opera.
Kamal Khan Conductor at the Teatro Colon, Teatro Municipal of Rio de Janeiro, Teatro de las Bellas Artes in Mexico City and through out Spain, South Africa and the United States.
Bernard Uzan Stage Director, Artistic Director of l'Opéra de Montréal, l'Atelier Lyrique de l'Opéra de Montréal and co-Artistic Director of the Florida Grand Opera Young apprentice program.
Renaud Doucet Stage Director/Choreographer.
Lucy Arner Coach at the Metropolitan Opera, Conductor & Artistic Director of the New York Chamber Opera.
Liora Maurer Coach at the New York City Opera.
Eric Trudel Coach at l'Opéra de Montréal, teacher at the Tokyo University and concert pianist.

fré|quen|ces|@|pont|saint|esprit reserves the right to substitute teachers for reasons beyond its control.

fré|quen|ces|@|pont|saint|esprit is also a cultural event about sound, voice and contemporary art whose patron is Norman Rosenthal, Exhibitions Secretary and Curator of the Royal Academy of Arts, London, and Trustee of the Covent Garden Opera.

'The goal of fré|quen|ces|@|pont|saint|esprit is to help singers and coaches, who are working to become professional performers, putting them in contact with renowned professional singers, coaches, rehearsal pianists, teachers, conductors and stage directors, coming from major opera companies and schools, who can share their practical experience and knowledge of the opera field.' **Renaud Doucet** Artistic Director

fré|quen|ces|@|pont|saint|esprit

Vocal summer program, Provence, France
18 June–15 July 2001

Summer repertoire 2001
French opera, French Art Song and Verismo Repertoire

Poster 1

fré|quen|ces|@|pont|saint|esprit

Lu cy Ar ner Re naud Dou cet
De ni se Du pleix Stef ka Ev sta tie va
An ne Grap pot te Ka mal Khan
Lio ra Mau rer Vic tor Di Ren zi
Dia na So vie ro Ber nard U zan
Mal colm Wal ker french art song
french o pe ra ve ris mo sum mer
school Pro ven ce Fran ce

Le prieuré
25 June 2001

Poster 2

fré|quen|ces|@|pont|saint|esprit

Lu cy Ar ner Re naud Dou cet
De ni se Du pleix Stef ka Ev sta tie va
An ne Grap pot te Ka mal Khan
Lio ra Mau rer Vic tor Di Ren zi
Dia na So vie ro Ber nard U zan
Mal|colm|Wal|ker french|art|song
french o pe ra ve ris mo sum mer
school Pro|ven|ce Fran|ce

Poster 3

fré|quen|ces|@|pont|saint|esprit

Lu cy Ar ner Re naud Dou cet
De ni se Du pleix Stef ka Ev sta tie va
An ne Grap pot te Ka mal Khan
Lio ra Mau rer Vic tor Di Ren zi
Dia|na|So|vie|ro Ber nard U zan
Mal colm Wal ker french art song
french o pe ra ve|ris|mo sum mer
school Pro|ven|ce Fran|ce

Poster 4

fré|quen|ces|@|pont|saint|esprit

Lu cy Ar ner Re naud Dou cet
De ni se Du pleix Stef ka Ev sta tie va
An ne Grap pot te Ka mal Khan
Lio ra Mau rer Vic tor Di Ren zi
Dia na So vie ro Ber|nard|U|zan
Mal colm Wal ker french art song
french|o|pe|ra ve ris mo sum mer
school Pro|ven|ce Fran|ce

Poster 5

fré|quen|ces|@|pont|saint|esprit

Lu cy Ar ner Re naud Dou cet
De ni se Du pleix Stef ka Ev sta tie va
An ne Grap pot te Ka mal Khan
Lio ra Mau rer Vic tor Di Ren zi
Dia na So vie ro Ber nard U zan
Mal colm Wal ker french art song
french o pe ra ve ris mo sum mer
school Pro ven ce Fran ce

Poster 6

fré|quen|ces|@|pont|saint|esprit

Lu cy Ar ner Re naud Dou cet
De ni se Du pleix Stef ka Ev sta tie va
An ne Grap pot te Ka|mal|Khan
Lio ra Mau rer Vic tor Di Ren zi
Dia na So vie ro Ber nard U zan
Mal colm Wal ker french art song
french|o|pe|ra ve ris mo sum mer
school Pro ven ce Fran ce

Previous pages
Gigi Obrecht, David Karam, Adam Kiryk, Post Tool Design, *Variations*, 2001
For this 'drawing machine' installation – inspired by Tristan Tzara's 'How To Make a Dadaist Poem' and shown as part of an exhibition at the San Francisco Museum of Modern Art – Post Tool used a re-wired organ, two computer monitors and a multimedia program. As David Karam explains, 'The software allowed the computer user to create compositions, extended across and between two monitors, using music, color, visual symbols, abstract graphical gestures and sound effects.'

Opposite page and above
David Tanguy, Sebastián Martinez Campos, Regine Stefan, Praliné, *Frequences @ Pont Saint Esprit*, 2001
For this poster series (for a French 'sound art' festival) Praliné worked on associations between colours and musical notes, much as the nineteenth-century French poet Arthur Rimbaud drew links between colours and vowels. 'For each tone in the chromatic scale there is an equivalent colour value,' elaborates Tanguy. 'The general information in the posters was printed in black. The second colour changed every week, using the different values specified in the chromatic scale.' One of the posters shown denotes the note F as ultraviolet and hence appears to have no colour.

Below and opposite page
**Designer: Gail Swanlund; design
assistant: Drew Hodgson; California
Institute for the Arts art director:
Scott Taylor, CalArts catalogue, 2002**

'In this catalogue, the decorative/ embellished elements are pulled from the number of people walking into a given studio,' recalls Gail Swanlund of the system she conceived for the CalArts catalogue, which was informed by and based on the 'real-life patterns' and movements of CalArts students. 'I stationed myself at points in the school where people passed through during a given time (about five minutes), and using the quantity of humans, their movements and gestures through the space, I duplicated or represented those moments with decorative elements. In other words, one person = one decorative element.'

LOS ANGELES AREA ARTISTIC and CULTURAL RESOURCES

Selected museums

The Museum of Contemporary Art
Los Angeles County Museum of Art
The Getty Center
Norton Simon Museum
Santa Monica Museum of Art
Museum of Latin American Art
Pacific Asia Museum
Japanese American National Museum
Southwest Museum
Fowler Museum of Cultural History

Selected concert halls

Walt Disney Concert Hall (opening in 2003)
Dorothy Chandler Pavilion
Royce Hall
Orange County Performing Arts Center
Cerritos Performing Arts Center

Selected theaters

Ahmanson Theatre
Mark Taper Forum
South Coast Repertory Theatre
Geffen Playhouse
Pasadena Playhouse

More than 20 additional large theaters

More than 100 non-equity theaters

Selected Arts Organizations

Los Angeles Philharmonic
American Cinematheque
The Getty Research Institute
Los Angeles Contemporary Exhibitions
Los Angeles Theater Center
Dance Resource Center of Greater Los Angeles
The Coburn School of Performing Arts

Other Resources

More than 100 art galleries

More than 50 jazz venues

More than 25 African, Latin and
world music venues

THE LOS ANGELES METROPOLITAN AREA

CalArts' close proximity to Los Angeles gives students ready access to the rich artistic and cultural offerings of the second-largest metropolitan center in the U.S. The city's abundance of performing arts organizations and venues, galleries, libraries, museums and research institutions presents a diverse range of educational and professional resources in film, music, art, theater and dance. This allows CalArts students to experience the arts at the highest levels and seek out future professional opportunities.

LOS ANGELES ci.la.ca.us
TOPOGRAPHICAL AND OTHER MAPS mapping.usgs.gov
WEATHER cnn.com/WEATHER/sw/CA/SantaClaritaCASC.html
HOLLYWOOD SIGN LIVE hollywoodsign.org/webcastcom

Join us as ITP students present
examples of their production work,
including multimedia installations,
physical and virtual interaction design
demonstrations, and sound and video
design works.

721 Broadway at Waverly Place
4th floor, South elevators
New York, NY 10003

Please call 212 998 1880 or
email itp.inquiries@nyu.edu
with questions

http://www.itp.nyu.edu

Interactive Telecommunications Program
Tisch School of the Arts
New York University

ITP Winter Show 2002

December 16–17
6–9 PM

David Reinfurt, ORG Inc., Poster and postcard series for New York University Interactive Telecommunications Program, Fall 2001

The graphic identity for the NYU Interactive Telecommunications Program is, as David Reinfurt explains, 'a computer program that shifts and recombines the six words of the program's name in a fluid and unstable syntax. The posters and postcards are automatically generated according to a set of parameters including line density, output size and maximum recursions. I have designed a programmatic system for making work that takes some of the formal decisions out of my hands and gives them to the computer program.'

No. 25

In Book III of Gulliver's Travels, a magician enables Gulliver to summon classic al figures from the dead In talking to them, Gulliver discovers that popular accounts of history are riddled with errors. He says, "...how low an opinion I had of human wisdom & integrity, when I was truly informed of the Springs and motives of great enterprises and revolutions in the world, and of the contemptible accidents to which they owed their success."

Above
**Concept: Christian Küsters; art
direction: Anja Lutz; designers: Christian
Küsters, Julia Guther and Anja Lutz,
Doubletake, published by *shift!*, 1999**
'We asked photographers around the
world to document a day in their life,'
says Anja Lutz of the idea behind this
issue of Berlin-based publication *shift!*
(cover shown), 'by taking a frame
every 20 minutes, rewinding the film
and sending it to a second person in
a different country who repeated the
process. The double-exposed film was
returned to us undeveloped so that
none of the photographers knew
the results.'

Opposite page
**Peter Saville, Paul Hetherington,
Howard Wakefield, Peter Saville Studio,
Waste Painting number 2, courtesy of
Emmanuel de Buretel, 1998**
The *Waste Paintings* series harks back
to 1998 when Howard Wakefield and
Paul Hetherington discovered that
by applying the random feature of
a Photoshop filter – each having
900x900x900 unrepeatable options
– varying degrees of unpredictable
beauty emerged. The *Waste Painting*
shown features a 'digital shredding'
of all the New Order album covers
that Peter Saville has designed for
the band.

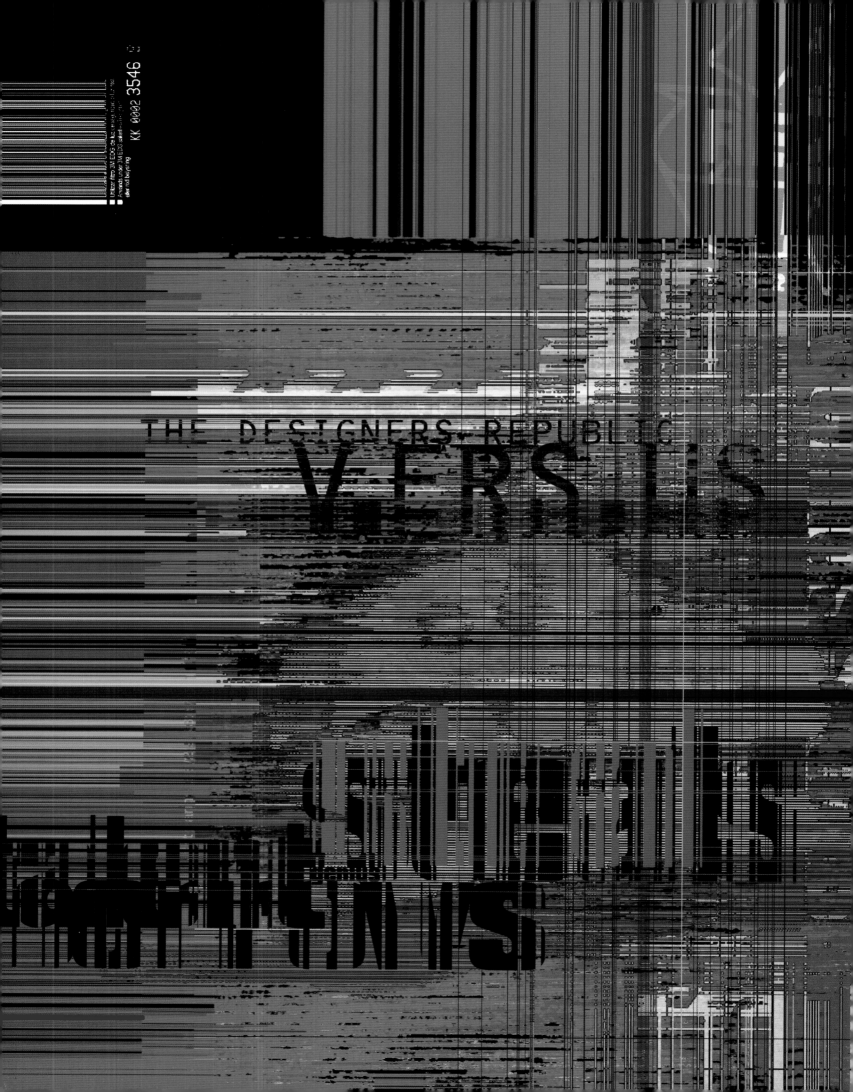

>>TALENT BORROWS. GENIUS STEALS.
SHIT COPIES.

100% DR:UK
THINK FOR YOURSELF!
© 1996 DR.

SUN DANCE

January 18 – 28 20000000000000000001 Park City Utah

A FRIEÑD (FELLOW MUSICIAN MIKE WATT) LEFT A SERIES OF MESSAGES ON SONIC YOUTH'S OFFICE ANSWERING MACHINE. ONE OF THE BAND MEMBERS ACCIDENTALLY LEFT A BROKEN AMPLIFIER ON OVER NIGHT TH3 HISS & CRACKLE OF TH3 AMPLIFIER COMBINED WITH TH3 ANSWERING MACHINE MESSAGES MAKE UP THE TRACK "PROVIDENCE" ON THE ALBUM DAYDREAM NATION

Previous pages
The Designers Republic, *Talent Borrows, Genius Steals, Shit Copies Number 5*, **1996**
Stealing the title in part from Charles Bukowski's *Tales of Ordinary Madness*, the Designers Republic describe the process behind the work shown (which appeared in *Creator Magazine*, UK) as, 'Encouraged. Planned. Random. Uncontrolled. Technology. Abuse. Deterioration.'

Opposite page and above
Martin Venezky, Appetite Engineers, Sundance Film Festival, 2000
For the Sundance Film Festival identity, Appetite Engineers used a broken spirograph to generate many of the images. As Venezky explains, 'We listed some of the specific features of independent film – low budget, simple materials, do-it-yourself sensibility ... And we interpreted these ideas very abstractly, using very basic material and low-tech processes which we did ourselves – photograms, drawing collages. As an attempt to stack the odds against perfection that a toy like the spirograph promises, we chipped away at some of the gears, brought objects in to jam the machine and worked on top of unsmooth surfaces. So we tried to do a good job with a broken machine!'

wanna be
up the wall!
broken
don't understand
the civil war
stick it all up!
you even know
rock 'n' roll
it's alright care
your
suits
your
beat
go to the vet!
hear your song
eh!
beat
up the stairs
to that
looking for a home
frenetic
off the streets.
comes marching home screwhead
ammunition field
open up Sunday
behind
you don't
away
another
changed button,
in the sun
tongue
come
corazón back
sacrifice
station light
afternoon
eh!
shoot say go 'ead
gonna feel it alright now
song, wrong

I went to the airport to meet Günther Förg and he wasn't there. Many telephone calls later I discovered that he was still at home, as he wife had just given birth. The installation of his show, due to begin that day, was discussed with his gallerist on the telephone. When he arrived for the opening, Günther had a look around, cursorily told me that it all looked good, and that was the end of the matter.

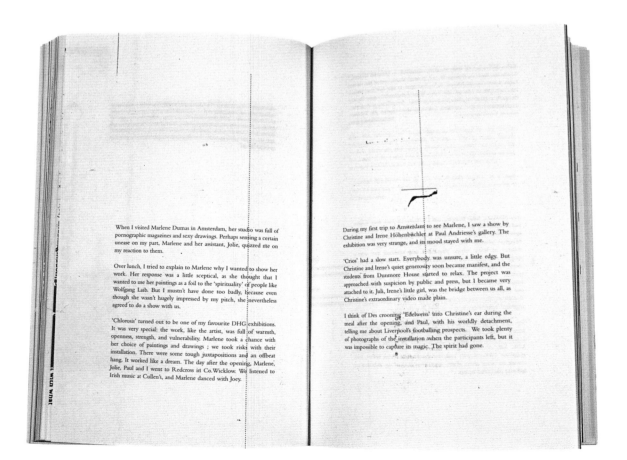

When I visited Marlene Dumas in Amsterdam, her studio was full of pornographic magazines and sexy drawings. Perhaps sensing a certain unease on my part, Marlene and her assistant, Jolie, quizzed me on my reaction to them.

Over lunch, I tried to explain to Marlene why I wanted to show her work. Her response was a little sceptical, as she thought that I wanted to use her paintings as a foil to the 'spirituality' of people like Wolfgang Laib. But I mustn't have done too badly, because even though she wasn't hugely impressed by my pitch, she nevertheless agreed to do a show with us.

'Chlorosis' turned out to be one of my favourite DHG exhibitions. It was very special: the work, like the artist, was full of warmth, openness, strength, and vulnerability. Marlene took a chance with her choice of paintings and drawings ; we took risks with their installation. There were some tough juxtapositions and an offbeat hang. It worked like a dream. The day after the opening, Marlene, Jolie, Paul and I went to Redcross in Co.Wicklow. We listened to Irish music at Cullen's, and Marlene danced with Joey.

During my first trip to Amsterdam to see Marlene, I saw a show by Christine and Irene Hohenbüchler at Paul Andriesse's gallery. The exhibition was very strange, and its mood stayed with me.

'Crios' had a slow start. Everybody was unsure, a little edgy. But Christine and Irene's quiet generosity soon became manifest, and the students from Dunmore House started to relax. The project was approached with suspicion by public and press, but I became very attached to it. Juli, Irene's little girl, was the bridge between us all, as Christine's extraordinary video made plain.

I think of Des crooning 'Edelweiss' into Christine's ear during the meal after the opening, and Paul, with his worldly detachment, telling me about Liverpool's footballing prospects. We took plenty of photographs of the installation when the participants left, but it was impossible to capture its magic. The spirit had gone.

Previous page, left
Michael Worthington, Clash poster,
made possible in part by a grant from
the City of Los Angeles, 2002
Michael Worthington, using song
lyrics as the basis for typographic
experimentations and systems,
designed this Clash poster for an
exhibition in Los Angeles. The poster,
in his own words, is made up of 'all
the Clash lyrics layered together. The
x-height masses are layered in such a
way to form a negative line through
the work.'

Previous page, right
Nina Nägel, Park Studio, Mass-
Production of Typefaces, 2001
Nina Nägel designed this family of
new typefaces by using a system of
filters and tweaks to morph existing
typefaces (in this case, Arial) into new
ones. Of the numerical system she
works to, she says, 'I use a random
generator which assigns numbers
within the parameter you've set. Then,
I choose 9 different filters and the
existing typeface. Based on the
number that has been generated (set
anywhere between 1 and 19), I apply
the filter to the typeface. If the number
is between 10 and 19, this means
I apply 2 filters to the typeface. 215
new typefaces were created using this
random number generator.'

Peter Maybury, Peter Maybury (Studio),
The bread and butter stone,
Douglas Hyde Gallery, 1997
The text in this book, designed for the
Douglas Hyde Gallery in Dublin, is a
collection of memories and reflections
on the gallery's programme over a
five-year period. As Peter Maybury
explains, 'To capture the feeling of
memories and their uncertainty, I
pasted together paragraphs of text
with textures/ images and fed them
repeatedly through a thermal fax
machine. By rewinding the roll, some
30 metres of unpredictable, multi-
layered text/noise was produced.'

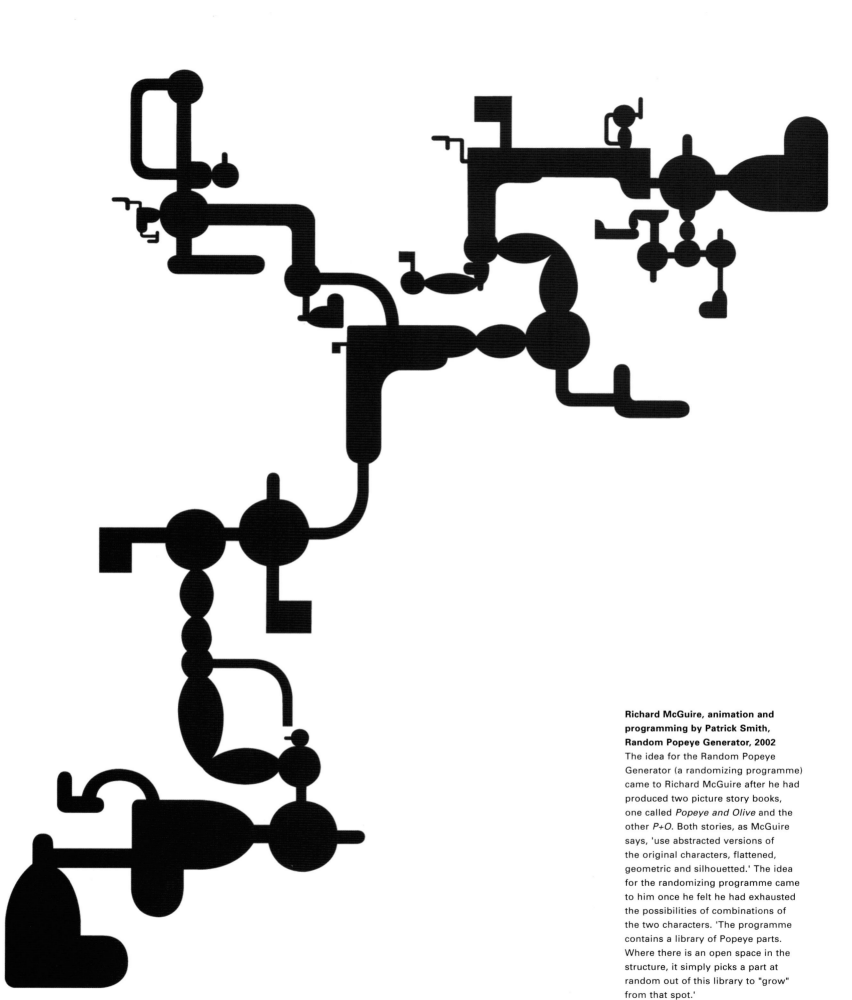

Richard McGuire, animation and programming by Patrick Smith, Random Popeye Generator, 2002
The idea for the Random Popeye Generator (a randomizing programme) came to Richard McGuire after he had produced two picture story books, one called *Popeye and Olive* and the other *P+O*. Both stories, as McGuire says, 'use abstracted versions of the original characters, flattened, geometric and silhouetted.' The idea for the randomizing programme came to him once he felt he had exhausted the possibilities of combinations of the two characters. 'The programme contains a library of Popeye parts. Where there is an open space in the structure, it simply picks a part at random out of this library to "grow" from that spot.'

Les miroirs universels créent des lieux

Tous les trés sombres photographes composent brumeusement un journal

Alle donkere ficties hebben verwachtingen

De psychologische landschappen zijn grensoverschrijdend.

Story suffers

Conceptual alternatives report such a picture.

Chaque immigration convaincante

L'atmosphère tendue transforme la photographie de manière colorée. Amsterdam travaillant les elements complexes, à travers l'éclairage intensifié.

The public outdoors travelling precisely

All almost true stories report some narrative news, since the perspectives have every object. Thematical aesthetics contrasting culturally.

Universal traffic

Such gloomy genres transport every mysterious politic.

Publieke spanningen symbolisch

De Europese spiegels transformeren het narratieve beeld.

Some glossy traffics, perhaps

The somewhat comprehensive suspenses work the component, or UN culturally explores the gloomy cibachromes

Tous les vrais réfugiés composent

Land Rover explore les N.U., cependant le symbôle poétique illustre culturellement une émigration.

Immigrations sentimentales, objets saturés

Verwarring overweegt afwezigheid

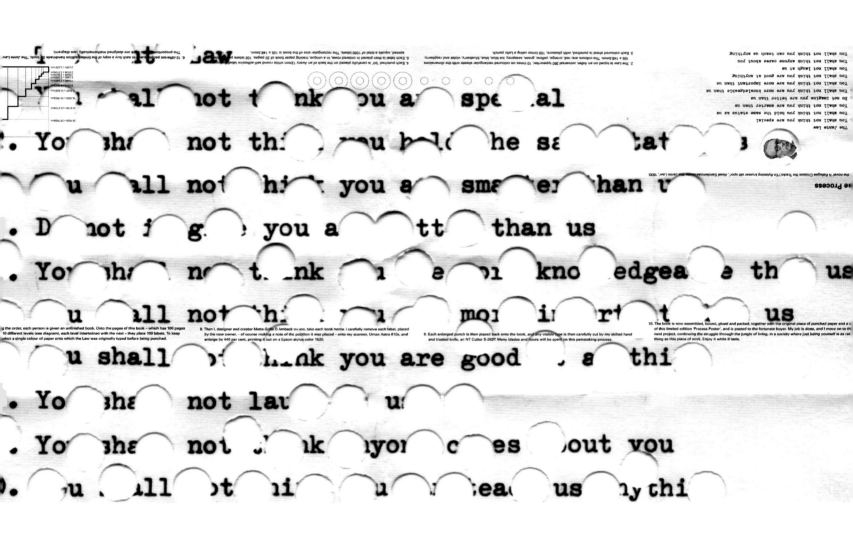

Opposite page

Thomas Buxó, photographer Juul Hondius, *A Complex Newspaper*, 2002

For this collaboration, Thomas Buxó asked Hondius to send him a list of key words that he associated with his photographs. The 'newspaper' (the result of their collaboration) was designed using a random-text generator. 'Randomly picked words were assembled by the software,' Buxó explains, 'which then generated sentences, closely following rules of syntax. Even the title, *A Complex Newspaper*, was dictated by an arbitrary decision of the machine.'

This page

Mette Ambeck, Hole Punch poster/ The Process, 2002

For Hole Punch poster, Ambeck reproduced 'The Jante Law', a social code/law dreamed up by Danish author Axel Sandemouse in 1933, on her typewriter. She punched holes in the text with a hole punch and then enlarged each 'punched hole' by 1,500 per cent, distorting and subverting the rigidity of 'The Jante Law'. As Ambeck says, 'Through this process, I have created new variations and versions of the law.'

wed. Admission: $500
FEB 10
AIGA members free
Cranbrook Academy of Art
Museum Auditorium
(use lower entrance)
7:30 pm

(D)
Ch A er
apt
Detroit
AIGA
A
PRESENTS
(F)
(E)

Cranbrook Academy of Art Department of Design •
Cranbrook Academy in collaboration with

Ed(Mr. Fo... ... a graduate of Cass Technical High School. Center for Creative S...
We Be T He Would Like You To Hear The Beautiful Things he S...

162

one night
one
one ed

IMITATE

(L) (L)—(A) Currently on the faculty of

The

California Institute of Arts

THE LAND

nd Cranbrook Academy of Art

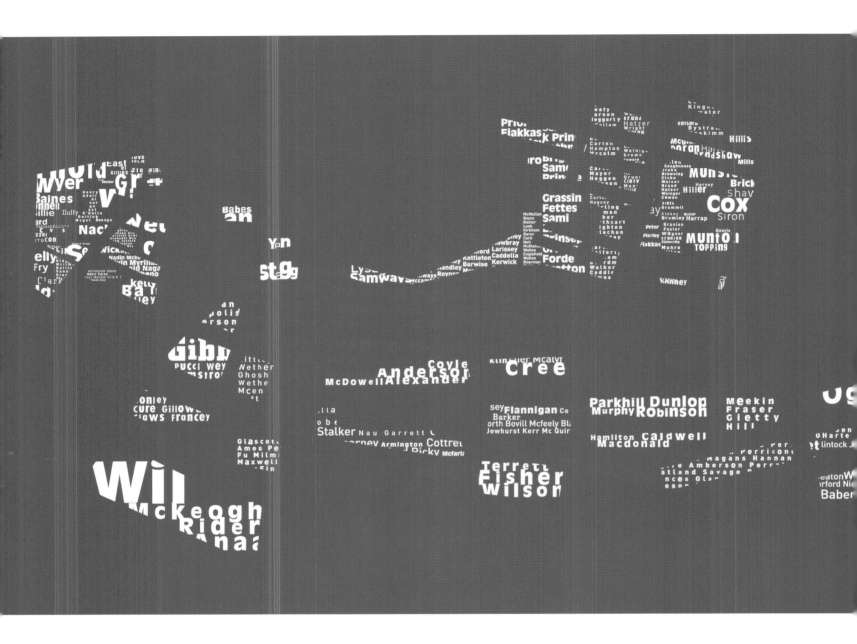

Previous pages
David Shields, Viewers Like You and Martin Venezky, Appetite Engineers, Ed Fella announcement card, 1993
Shields and Venezky wanted to 'announce Ed Fella's return to the Cranbrook campus with a card that celebrated the spirit of his work'. Shields remembers, 'As we collaborated, the design was passed back and forth, responding to each others' moves. In this sense the card is as much a dialogue between designers as it is an artefact.'

Above
Peter Anderson, Interfield,
***Moving Surnames*, 1999**
Anderson used all the names in a Northern Ireland phone book as the basis of the design for Cayenne, a new restaurant in Belfast. Anderson took the names and reassembled them into a selection of areas from a Belfast street map, using the two parameters to allow for unexpected stories to unfold by putting the different names together and encouraging unpredictable shapes and patterns to emerge. The finished design graced not only the restaurant's menu, but also a sixty-foot wall within the restaurant itself.

23. Berlin-based musician Stephen Betke, also known as Pole, uses a broken Waldorf Pole Filter (hence the nickname) as the basis for his music. Apparently, he was given the synthesiser as a present and soon after it fell down on the floor and broke. He's used the broken equipment ever since, siphoning sound through the broken filter, which when treated leads to hisses, crackles, static: a sonic product now considered his trademark.

**Matthias Ernstberger, Eva Hueckmann,
Doris Pesendorfer, Stefan Sagmeister,
Sagmeister Inc.,** *Everything I Do
Always Comes Back to Me*, 2002

'This project was a true collaboration
within the studio', Stefan Sagmeister
says of these six spreads, designed
for an Austrian magazine. After
Sagmeister sketched out each of the
spreads, Eva Hueckmann then made
the 3-D type models. 'I asked Eva to

get snails (with houses) for the last
spread,' Sagmeister recalls of the
unexpected twists and turns that
arose from the collaboration, 'and
she came back with strange, Chinese
fish worms instead … so I said great
… use them anyway.'

Paul Donald, Graphic Detail, 02/22/02, 11/24/01, *Daily Diptychs*, 2002

'The *Daily Diptych* is my name for a pair of photos taken on a single day,' Donald says of the two pairs of photos shown. 'I carry at all times a digital camera and shoot whatever comes into view that I find interesting. To select the ten pairs of photos for submission to this book, I created a "low-tech randomizer" in my studio.

This consisted of two bowls each filled with bits of paper. Scribbled on the bits of paper were numbers. In selecting the diptychs, I randomly chose a number from Bowl 1 and Bowl 2 to come up with a month and day. If there was a diptych for that day, that one got submitted. If not, I continued.'

Margarita Barrios Ponce, Response to 'Flow' brief, 2001

The work shown by Margarita Barrios Ponce (opposite page), Jonty Valentine and Min Choi (following pages) was their response to a brief set for them by Allen Hori when they were students at Yale University. Hori, who teaches a graduate typography class, assigned the students a brief entitled 'Flow'. 'I asked my students to literally collapse a bunch of files together so that they begin to see relationships, juxtapositions, alignments created through pure chance, and then have to make their way through these happy accidents and produce something viable from a dense mass of visual and verbal information.'

the la
in bajó a
e
due m t t e
mo n agne h
ma r la a
bajó al ma e
montaña b
sea la mon

st

K →

des c n d u e à l

descendue

la montagne e
a bajó al mar
ea a montaña bajó
e s t the sea la
ntain met the sea
he mou ntain met th
mountai
mer th

montag

onta gn m

met the se
sea
M
t

met t ou
er tla mer
me à
e est
tagn ar l a montagne e
m bajó al mar
ea a montaña bajó
he sea la montañ

the mounta

r

la

mer

the
mou

the mountain
met
the se

mountain
sea la monta
l mar la m

Column 1

I.

1. a.

a 1000
c 1200
a 1250

a 1400-50
1554
1667

1704 1793

1854
zi
1859

b. See FLOWING
1697

c.
1603
 1666
 1786
 1817
1845

d.
1526
 1606

e.
1885

† 2. a.
c 825
 a 1225

1641
 1737
† b.
1434
 1500-20

c.

d.

1887

 1894-5 1888

1897
 1901
 1914
 1932

3. a.

1382
 1388
 1611 BIBLE
 1613
 1742
 1817
 1878
 1890

b.

1382
 1548
 1560 BIBLE

Column 2

1607 1651
 1717
 1780
 1833 1816
 1878

4.

1585
 1643
 1737 1859

 1870

5.

1606
 1648
 1697
 1712
 1782
 1810
a 1881

6.

1715
1758
 1606
† 7. a.
1413
 1477

 1635

1382 1477 c.

d. (See quot.)
1883

II.
8. a.
c 825
 c 1000
 c 1250
 a 1400-50
 1574 1578
1591
 c 1724
 1813
 1828

b.
c 1200
 a 1240
 1535
1609

 1382

 1632

 1682

 1794
 1818

1888

c.

1677 1863

† d. use in 14 below

Column 3

1550
1906

9.

1754-64 [see CATAMENIA]. 1894

III.
10.

EBB *v.*
quots. 1627 and 1721). Cf. FLOOD
c 1050 (1885)
 c 1200
 c 1430 1568

 1624
 1626
 1627 —— 1691

1608 ——
 1721-1800
1667 1739
 1816 1830
 1884
1399
 1600
 1786 1817
 1820
See FLUENT † 11. a.
1828
 1398 *a* 1625
 1590
 1606
 1615
b.
quot. *c* 1510 (see

 Cf. HIGHFLOWN.

c 1510
a 1656
 1667
1725
 1879
† 12.

a 1225
a 1240
 c 1600
 c 1689 1710
 ₱ 3.
13. †
c 1000
 1490
 1667
 1782 1817
1824

14. († *in*, † *of*)
1545

1713 1382
 1388 —— 1388
 c 1400
 1539
a 1592
 1678

15. a.
1864 1382
 1666
 1712
 1845

see
(see

II

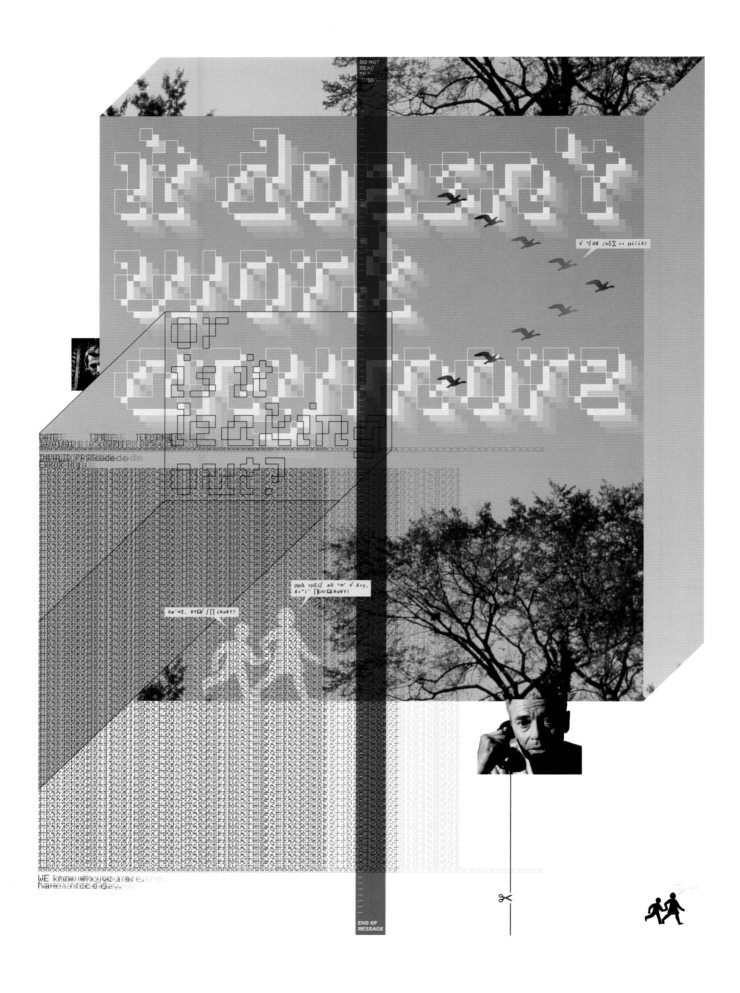

Inside the poster image:

DECEMBER 3 — 31

CHARLES SWANSON
SARAH ROSSITER
MARCOS ROSALES
100X5 BETTER
DAVE MULLER
EXPEDIENTIA
DEWEY AMBROSINO ORGANIZED BY
MICHAEL GUMP

WALL TO WALRUS

FURNISHING AND RELATED INSTALLATION

INSHALLAH 244 S. MAIN ST. LOS ANGELES CA. 90012
213 625ARTS BETWEEN 2ND AND 3RD ST. DOWNTOWN

Previous pages
Jonty Valentine, Response to 'Flow'
brief, 2001

Opposite page
Min Choi, Response to 'Flow'
brief, 2001

This page
Gail Swanlund, Swanlundia and Geoff
Kaplan, General Working Group,
***Wall to Walrus*, 2001**
'The initial seed for this project [back
of invite shown] was the blow-up
scene in *Zabriskie Point*,' says Los
Angeles based Gail Swanlund of this
cross-California collaboration with San
Francisco's Geoff Kaplan. 'In that
scene, everyday life is exploded in
the air: vegetables, a favorite shirt,
reading lamp, dog bowl; all fly apart
and through the air in the blast. Kids,
often referred to as tornadoes, take
what we know as ordinary and throw
it in the air, so Geoff invited his 4-year-
old niece to supply photos for this
project. The results are completely
unexpected and something we couldn't
have made ourselves without being
very self-conscious and stilted.'

28. The Beowolf typeface, by
Erik Van Blokland and Just
Van Rossum of Letterror, is
a typeface that gradually (and
seemingly randomly) deterio
rates and changes every time
its used. Using what Letterr
or call "random technology",
Beowolf is programmed to ap
pear differently each time it
is printed – giving the user
the sense that the typeface
is in a constant state of
flux.

'We wanted the design of the text
to reflect the random sources of the
original articles, without wearily
mimicking the type style of each
individual article,' Graphic Thought
Facility say of methods used to
design Stephen Bayley's book
General Knowledge. 'So we utilized
a controlled system: we selected five
random styles of layout for the book.
The decisions on where the type styles
changed were not governed by the
changing content of the text, but
rather by the natural divisions of the
printer's 16-page sections. This was
both economical, working with the
printer's planning, and created
"random" changes in style, often
halfway through the article.'

21.
Kenneth Goldsmith's book
Soliloquy (2001), is an unedited,
487 page tome of every single
word Goldsmith spoke for one
week in 1996. The book's open-
ing lines are : "Good morning,
how ya doing? Yep. Wait a
second, I have my ticket. Ok.
There you go. Thanks. See you
soon. Oh oh oh, I thought you
said have a good weekend. Oh
Ok, have a good week…"

21.
Kenneth Goldsmith's book
Soliloquy (2001), is an unedited,
487 page tome of every single
word Goldsmith spoke for one
week in 1996. The book's open-

the purposes of modern industrial design. A Bauhaus teapo
is both a geometry lesson and a sermon.

The apparent universality and implied timelessness
judgement is made less clear and more poignant by the clu
surrounding the poem. In trying to come to terms with the
beauty and decay (a concern of other poems, including 'Od
and 'Ode to a Nightingale'), and, 'saddened by the mutabi
beauty, he sought consolation in the more permanent beaut
the perception of value in art changes.

A century and more nearer our own time the pioneer
consultant Norman Bel Geddes, addressing the spirit of th
that if Keats had been writing in 1940 he would have said
an aeroplane as he had about that old Grecian urn. In the
scholastic philosophers construed beauty to be an attribu
than of urns or aeroplanes; beauty and art were not neces
indeed the idea of 'art' as a discrete activity was not a
Keats's neo-classicism, the prevailing taste of his day,
admire the Hellenic pot, while Norman Bel Geddes, suffuse
of the twentieth century, was as moved by the plane. In D
Geddes's contemporary, Walter Dorwin Teague, apparently w
compared one of the Texaco filling stations he had design
of Greece.

Each age finds its own expression in material thing
faculty we use to identify those we find palatable or rep
taste. With the spread of materialism, consumerism and co
fetishism, minute aesthetic criteria are being establishe
for general social competition for the first time in civi
Everyday things we consume are — if perhaps only briefly -
sombre resonance of great art.

Because it involves everything we do, taste can soo
neurosis. Just as quality in design is most conveniently
use of moralizing terms like honest, decent and sound, wh
origins in observations of human behaviour, taste is simi
performance, in that the exercise of it is somewhat akin
architect Viollet-le-Duc, an eloquent spokesman for struc
in building design, applied the same principles to person
believing that, '*Le goût consiste en paraître ce que l'on
que l'on voudrait être.*'

Semantically, taste is rich and confusing, its etym
interesting as that of 'style'. But while style — deriving
stylus or pointed rod which Roman scribes used to make ma
tablets — suggests activity, taste is more passive. The o
gustibus non est disputandum' (there is no disputing abou
oldest formulation of the idea 'One man's meat is another
It is primary evidence that since Roman days the matter o
involved choice, whether individual or collective. Today,

----- PAGE : 16 ---

aesthetic and social discrimination, as well as gustatory sensation. Etymologically, the word we use derives from the old French, meaning touch or feel, a sense that is preserved in the current Italian word for keyboard, *tastiera*.

In English, the term 'good taste', meaning 'sound understanding', appears in the early fifteenth century, but it is not until the seventeenth century that the concept of aesthetic discrimination arrived in England in the 1685 translation of Baltasar Gracian's *El Oraculo Manual y Arte de Prudentia* (1647). In which the term *'gusto relevante'* becomes 'quaint and critical judgement'. Interestingly, this book for the courtier has never been out of print since its first appearance, and, more interestingly still for a book devoted to the professional cultivation of charm, it was made most famous in the German translation of Arthur Schopenhauer.

The metaphorical use of 'taste' to mean judgement began in France, where Gracian's *'gusto relevante'* was rendered as *'le goût fin'*. A literal translation gave a new and troublesome word to English. The salons of France, where art, literature, antiquities and science were discussed in circumstances of considerable comfort and luxury, adopted the word and gave it a capital 'T'.

By the early eighteenth century the word 'taste' was becoming familiar in essays on literature; the major transformation was complete and 'taste' had become synonymous with judgement. A subtle and even elusive concept was born, elements of refinement and restraint attaching themselves to the definition only later.

The Earl of Shaftesbury's *Letter Concerning Design* is a typical marker of the phenomenon. It was published just as critical discernment was about to become an intellectual sport. The Letter was written when art had been separated from its didactic and divine purposes and was well on the way to becoming a consumer product. At this moment, taste did not have any particular values; it was only identified as a part of the human apparatus of discernment; you either had it or you didn't and there was no question of 'good' or 'bad'.

When man replaced God as the chief object of study, it was inevitable that the idea of beauty deriving from divine inspiration was replaced by a more secular, even materialistic, notion of aesthetic satisfaction. La Rochefoucauld remarked that 'Our pride is more offended by attacks on our tastes than on our opinions', an observation which puts into nice equilibrium the forces of cupidity and sophistication which dominate modern consumer behaviour.

But in a culture which had only one class with the economic capacity to make discriminating judgements, the matter of whether taste was 'good' or 'bad' was not so much irrelevant as inconceivable and its characteristics still wanted defining. Early pursuit of precision in this matter began by trying to locate where exactly in the body taste operated. To the Earl of Shaftesbury (1671-1713), having taste was like having an accessory for the soul. To Joseph Addison (1672-1719), as soon as taste was established, vice and ignorance would automatically be banished, presumably from loins and head – in that order.

David Hume (1711-86) – who had said of Shakespeare 'a reasonable propriety of thought he cannot for any time uphold' – defined taste as a 'sensibility' to every kind of beauty or deformity. Hume's view was that standards *could* be established, while Sir Joshua Reynolds (1723-92) upheld this view in the fine arts. Reynolds thought that genius and taste were very much the same thing, except that genius had the added ingredient of execution. To an academic painter like Reynolds, taste was to be found lurking in the same dominion as reason and was, therefore, in his view, equally exempt from any possibility of change.

The *Discourses* which Sir Joshua Reynolds delivered at the Royal Academy between 1769 and 1786 are a *tour de force* of aesthetic conviction; they are also the richest ground for sniffing out the English Enlightenment's attitude both to man-made rules and to God-given genius. Reynolds declared, 'Could we teach taste or genius by rules, they would no longer be taste or genius' (1770). But in grandly stating the case for rules, he made the most persuasive statement ever of the academic principle:

17

175

11. To create Andy Warhol's "Oxidation Paintings" (or ~~paintings~~ "Piss Paintings) Victor Hugo, Ronnie Cutrone and Walter Steding took turns urinating on canvases that were coated with wet copper paint. As the urine mixed with the ~~x~~ copper paint the canvases oxidised, turning orange and green. Many critics (not necessarily aware of the process) made comparisons between these 'Oxidation Paintings' and Jackson Pollock's work.

Fabrizio Gilardino and Umberto Cirrito, Socialist Designers, Socialist Designers poster, 2001
'We split the information between ourselves in such a way that neither of us had "complete" lines of text,' Fabrizio Gilardino remembers of the system that he and Umberto Cirrito devised for this poster series, one of which is shown. 'We then worked on the posters without knowing exactly what the other person was doing and we finally "pasted" the two halves of the posters together.'

tim he**cker**

kristian/shalabi/saint onge

francisco. LÓpez.

samedi **5 janvier**

2 1 h 0 0

8$/10$(porte)
(avance)

SALA ROSSA
4848, boul. Saint-Laurent

we thought you might wanted to know that this is a **Socialist Designers** poster designed by Fabrizio Gilardino and Umberto Cirrito : Montreal : December 2001

James Goggin, Travel Book, 1999

'I borrowed ten travel books from a library, sent each book to its respective subject country and had a recipient photograph it somewhere in that country, ask a librarian in a local library to stamp it and then send it back,' recalls James Goggin of the project he did as a student at the Royal College of Art. 'The only real proof of the project's process lies in the photographs from the participants and the library stamps.' Eight of the ten travel books and their corresponding packages are shown here. Incidentally, the book sent to Mexico was lost and therefore no package was ever returned.

**Rachel Collinson, Rechord,
Spirograph Drawing Program,
2000–2002**

'I was playing around in Director and
tried to recreate a spirograph drawing
program,' Collinson remembers. 'The
idea was to get a shape resembling
the tip of a felt tip pen or biro to draw
spirograph-style shapes on the
screen. Eventually, the idea evolved
away somewhat from the original
concept and started producing things
inside the computer that would be
impossible on paper.'

Sandy Ryan-Business Manager

032002RYA $NFS. Fine gauge, lightweight
wool. Slightly shaped. Machine knit. Hand
stitched. Dry clean. Available size M only.

Documents
Photographs
Love Interests
Regrets
Email

Leif Fairfield-Musician

032002J0H $NFS. Fine gauge, lightweight
wool. Slightly shaped. Machine knit. Hand
stitched. Dry clean. Available size M only.

Love Interests
Regrets
Future Plans

Brian Janusiak,
Fragmentation: heavy, 2002
Monitoring the actions and interactions
of a computer user over a period of
one month, *Fragmentation* (detail and
sketches shown) offers a particularly
modern portrait of an individual's life.
To achieve this, Janusiak worked with
software that re-orders fragmented
information. Next, the computer
generated an image from the
information, which was 'comprised
entirely of colour and represents all
actions and interactions a person
undertakes while using their
computer.' To complete this portrait,
a one-of-a-kind sweater was machine
knitted, based on the pattern of the
generated image, to fit the individual
that was tracked.

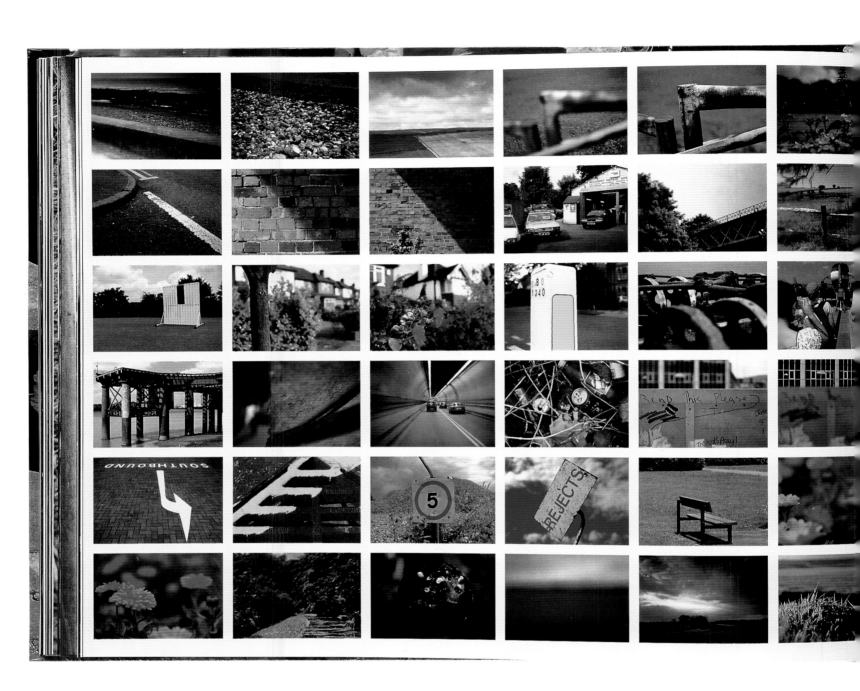

12} In 1981, Brazilian artist Waltercio Caldas designed Liuro Carbono (Carbon Book), a book made up of alternating heavy blotting paper pads and carbon paper sheets. As the white paper collects

ink from the carbon sheets, shapes and forms start to appear. These formations come about at random, determined by the weight of the paper, the way the reader handles the book, leaving each page open to an unpredictable outcome.

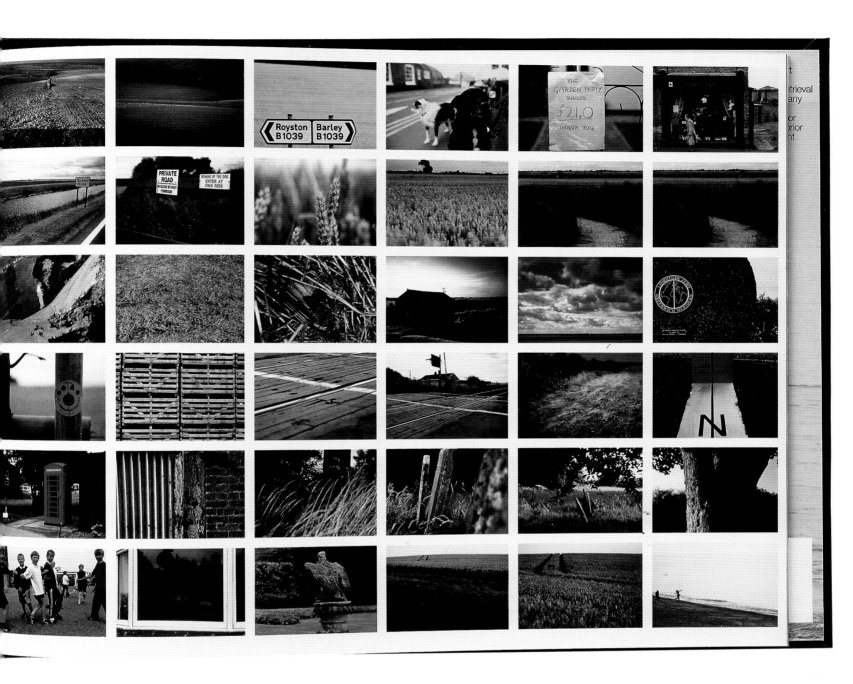

Scott Miller, Mike Turner, Browns,
Zero Degrees, **2000**
'Nothing was chosen for its particular
beauty or ugliness,' say Miller and
Turner of *Zero Degrees*, a collection of
photographs shot along the English
Meridian Line. 'Nothing was shot for
political reasons. The only arbiter was
the line.'

**Cody Schell and Russell Hrachovec,
CompoundEye,** *Communication,* **2002**
Communication is a collaborative
photography project by Hrachovec
(based in Brighton, UK) and Schell
(based in Iowa, USA). Once both
designers had selected the theme of
'communication' as the basis for their
collaboration, Schell then proceeded
to photograph anything that he felt
fitted the theme. He then sent the
exposed but undeveloped roll of film
to Hrachovec, who loaded the same
roll into his camera and double
exposed the film.

Rodger Stevens and Jordin Isip,
***Exquisite Day* project, 2001**

The invitation shown here is for the
Exquisite Day project, a collaborative
project by Rodger Stevens and
Jordan Isip, the latest in a series of
exhibitions for which the duo asked
multiple artists to produce work under
specific conditions. For the Exquisite
Day Project – a homage to the

Surrealists' Exquisite Corpses 'game' –
each participating artist was asked to
use the artwork adjacent to theirs
as the beginning of their individual
contribution. For the final exhibition,
work by 92 different artists became
seven multi-collaborative pieces.

Designers: Denise Gonzales Crisp,
Ethan Gladstone, Yasmin Khan;
art director: Denise Gonzales Crisp;
creative director: Stuart Frolick,
Art Center catalogue, 2000

'In the case of the Art Center at Night brochures [covers shown],' recalls Denise Gonzales Crisp, 'a very rigid grid system was developed so that rather than developing a system that minimizes the "worst case scenario", the system exploits it. In other words, let the so-called problems function as surprising and viable composition, juxtaposition, etc. Type bumps uncomfortably up against other bits of text, yet the system is consistent and the hierarchy well defined so these disturbances don't impact the read. Design decisions are made then based on promoting the awkwardness of these relationships, but only after those relationships have been determined by the system.'

**Christian Küsters, CHK Design,
Central Station, Milch Gallery, 2000**
Küsters was inspired by a timetable
at Liverpool Street train station when
creating this Milch Gallery catalogue
(cover shown). He explains, 'I took the
lines on the cover from a timetable at
Liverpool Street station. The rest of
the layout follows an easy system
which was set up prior to receiving
all the information. So the catalogue
designed itself.'

Central Station

14 September - 22 October 2000

Opposite page
Art director: Matthew McCarthy; designer: Andrew Trevillian; creative director: Ed Fella; Clear Design, *Similar Differences and Different Similarities*, 2002
Clear Design were one of a dozen studios invited to participate in a calendar design project conceived by Ed Fella while he was teaching at Monash University. Working to a fixed grid and assigned the month of December (by rules 'set' by Fella), Clear Design's response to the brief was inspired by their immediate environment. 'We started by looking at where we worked and the times of the day that we experience our broader environment. We often experience the surrounding streets when looking for a car park early at 9am. The second time in that day is lunch and the third returning home at 7pm. Each time, however, the street-scape changes.'

This page
Matt Fey and Kristina Meyer, Orangeflux, *Love Horse*, 1999
'Sound and graphics were combined in ways the viewer controls on his/her "boom box" control panel,' say Orangeflux of the screen grabs shown here, extracted from *Love Horse*, a digital recording on Codex Series. The viewer navigates three verses of the visual recording, clicking on elements in the play field and the boom box control panel to trigger sounds, lyrics and other elements.'

**Anthony Burrill and Paul Plowman,
Multiplex, *I'm Sorry, I Don't
Understand*, 2001**

I'm Sorry, I Don't Understand was a
video made for JAM: London/Tokyo
exhibition at the Barbican Gallery,
London (a selection of stills are shown
here). The video, according to Burrill,
was the result of a one-day two-wheel
cine-reconnaissance adventure. 'I spent
a day riding round London on my bike
filming "modern" buildings, cropping
them in abstract ways. Once the shots
had been selected, they were edited
together and the shots were all split
into two and swapped around (i.e. the
first frame is made up of one half of
the first shot and one half of the final
shot). This totally random effect gave
lots of interesting compositions ... we
didn't tweak any of them!'

Sorry,
I don't understand

METHOD 1
Bible

1. Enlarge the page on the right by 150% using a photocopier.
2. Place the resulting page on the copier and enlarge again 150%.
3. Repeat this process 500 times.

METHOD 2
JPEG Fucker

1. Open a JPEG image in a text editing program like BBEdit.
2. Copy, paste or delete any part of the text.
3. Save the file.
4. Open the JPEG in an image editing program.

 Repeat this process.

METHOD 3
Magic JPEG

1. Get the JPEG image at: www.lust.nl/methods
2. Open the JPEG image in Photoshop 6.0
3. Open any other image.
4. Close this image.
5. Resize the window of the Magic JPEG by pulling the window.

 Repeat this process.

Previous pages
LUST, special commission, 2003
special commission ~~special
commission special commission
special commission special
commission special commission
special commission special
commission special commission
special commission special
commission special commission
special commission special
commission special commission
special commission~~

		Term, 19...............		
			Position in Form...............	
No. in Form...............				
				Initials of Master/ Mistress
Subject	Term	Exam.	Remarks	
Art				
Biology				
Chemistry				
English Language				
English Literature				
French				
Geography				
German				
History			—	
Housecraft Handicraft }				

NO. 38.
FILM–MAKER HARMONY KORINE & ARTIST CHRISTOPHER WOOL COLLABORATED ON THE PUBLICATION, «THE BITCH CHICKEN». THE TWO COLLABORATORS PASSED KORINE'S PHOTOGRAPHS BACK AND FORTH, GRADUALLY ADDING, OBSCURING, MESSING UP EACH PHOTOGRAPH. ~~THAT HAVE~~ THE BOOK IS MADE UP OF PHOTOGRAPHS ThAT HAVE BEEN LAYERED, OVERPRINTED, PHOTOCOPIED, DRAWN OVER BEYOND RECOGNITION.

Richard Bates, David Shields, Brian Smith, Susanna Stieff, *Output*, 1991
Of his collaboration with Bates, Smith and Stieff to produce the second 'issue' of the *Output* publication, David Shields recalls, '*Output*, as a project, first pointed us to the possibilities of "game playing". The actual process of creating the publication was limited to the length of one day, though the four of us spent a few weeks gathering all types of printed information and ephemera.' Katherine McCoy later said of the project that the collaborators generated, 'a great team project about probability and randomness'.

Skill Check (continued)

How To

Using Tools

1. To create a picture box, select one of the picture box creation tools, ▭, ▢, ◯, or ⬡.

If you select the Rectangle Picture Box tool ▭, the Rounded Rectangle Picture Box tool ▢, or the Oval Picture Box tool ◯, click and drag the Crosshair pointer ✛ in any direction to create a box.

If you select the Polygon Picture Box tool ⬡, the pointer ▸ changes to the Crosshair pointer ✛. Click the mouse to establish the position of your first polygon vertex, then move the crosshair pointer to where you want to place the second vertex and click. (The second click also establishes the first line segment of your polygon.) Continue clicking to create additional vertices and segments. To close the polygon, move the pointer over the first vertex you created. The pointer changes to the Handle Creation pointer ⬦; click. You can also double-click to close a polygon.

Isaac Tobin, Transformers the Movie, 2001

The poster shown is one of a series designed by Isaac Tobin to the brief, Design Application Matrix, written by Nancy Skolos as part of the graduate Graphic Design course at Rhode Island School of Design.

The categories that made up Skolos's matrix were: Content, Inspiration, Constraints, Audience, Object. Considering 'the basic conditions and forces that impact a design solution,' she asked students to 'choose from among the above five scenarios or mix and match or modify to fit your interests.' Tobin responded as follows: Content (compositional studies), Inspiration (Jan Tschichold, transformers, characters), Constraint (found object collage, no overlapping pieces, only manipulated by cutting, combined with tape only), Audience (graphic designers, fine artists and collectors), Object (poster series).

'The compositions that emerged are both intuitive and random,' recalls Tobin. 'My system of constructing the posters consisted of laying my collected scraps and pieces next to each other like a jigsaw puzzle until they felt right.'

IAN ANDERSON

STUART BAILEY

April Greiman

Stefan Sagmeister

IAN ANDERSON

1. How would you define a mistake?

Error of judgement.

2. How would you define an accident?

Unintentional error.

3. How do you think mistakes and/or accidents add to the creative process?

They open unpredetermined horizons and create chance.

In what way have they added to your own work?

For The Designers Republic, the process is the adventure. We lose interest if we know where we'll finish when we start.

4. Do you think technology encourages or discourages accidents?

It doesn't encourage or discourage. If abused, it can facilitate or pre-empt chance and unforeseen results.

5. John Cage was the 'pioneer' of creating systems that 'encourage the outcome of which cannot be foreseen.' Have you used systems in your work? If so, what were they how did you use them?

We prefer to instigate individual situations rather than develop systems. An accident is only an accident the first time.

6. In keeping with the idea of creating systems, do you think it is possible to 'get out of your own way'? If so, how?

Hypothetically it may be, but that opens questions relating to determinism. Theoretically it can be achieved by randomizing source material to filter.

7. What do you think is interesting, or appealing about the 'unpredictable'?

That it isn't predictable.

How has the unpredictable added to your work?

That it isn't predictable, for us.

8. What role do you chance has both in the general creative process, and in your own creative process?

It depends to what degree you accept chance over causality. Theoretically, chance precipitates an unplanned shift in thinking, creates unintentional ideas and a creative dialogue between the planned and the unplanned …

9. Do you think we can do anything encourage chance?

Yes/no.

10. Do you think there's a relationship between accidents and chance?

Yes.

Can you give an example from your own work? From someone elses work?

We're not that interested in the specifics of individual 'expressions' of chance.

STUART BAILEY

Your questions are too difficult to answer directly because I never think about these things, or maybe I try not to. I once started to write something about chance but it just dissolved into nothing. Now I'm more interested in making work than writing about it. I don't know – you just hope things happen naturally, without forcing them, and trying to pinpoint them doesn't help. I think its possible to be more or less open to accidents, mistakes, chance, whatever. Maybe it's like sleeping with one ear awake, just in case. The closest I can describe my relation to these things is that while following a particular direction in a piece of work – trying to sustain a route – trying to avoid dead-ends – little details seem to confirm the right track. I'm going to leapfrog questions 1–9 and describe something that happened this week which might sum up the rest.

10. DO YOU THINK THERES A RELATIONSHIP BETWEEN ACCIDENTS AND CHANCE/ CAN YOU GIVE AN EEXAMPLE FROM OWN WORK/ FROM SOMEONE ELSES WORK/

I co-edit and design a magazine called *Dot dot dot*. Although against the idea of having explicit themes, we usually end up with a lot of links – reverberating ideas – between pieces in each issue. When this is happening I almost feel afraid to notice it in case the acknowledgement kills it. An odd superstition. The patron saints of the issue we're currently working on seem to be Karl Marx and Jean-Luc Godard, which are tied together in a piece called 'The Beatles vs Stones dialectic', a bizarre Marxist analysis by Ian Svenonius, singer in Washington DC band The Make-up. ~~bizarre Marxist analysis by Ian Svenonius, singer in Washington DC band The Make-up.~~

Another thing I'm busy with is a proposal for a music performance based on updating the love–hate list Malcolm McLaren and Vivienne Westwood printed on an infamous t-shirt in the 1970s, to be read over a piece of music which should resemble a track called 'One + Two' by Francis Van Litsenborgh and Judith Sraer on a compilation album *Manifeste* released by the music wing of Paris fashion label APC. Over a slow, churning backing track, a male voice reads a list of philosophical statements such as 'The pounding of drums on certain Caribbean islands reveal what's really going on', to which a female voice replies either 'yes' or 'no'. This is a pastiche of an interview scene in the film *One + One* by Godard – a documentary of the Rolling Stones recording 'Sympathy for the Devil', interspersed with a few political set pieces.

Last week we made the proposal for our music performance to the curator of a local gallery. We needed to play him this track to give an idea of the sound, but I didn't have the CD – I'd always heard it at other people's places – so I spent the afternoon calling various people to get them to send me the song file by email, but nobody had it with them. A couple of years ago I met the designer of the cover of the *Manifeste* CD, Rik Bas Backer, who works in France. As a last ditch attempt I mailed him, stating that if he received the email immediately and had the track, he'd have to act fast because our meeting was within the hour. Five minutes later I received an MP3 from him.

The meeting with the curator went well. At the weekend I rented *One + One* in order to take some stills to accompany the aforementioned text, which questions Godard's reason for choosing that particular song. While doing so it occurred to me that it might be interesting to transcribe either the *One + One* or 'One + Two' interview for *Dot dot dot*. The one in the film was too long and complex, but the one on the CD seemed perfect.

After transcribing it, I thought I should ask permission to use it, so mailed Rik back to thank him properly for sending the MP3 and to ask whether he thought I'd be able to use the lyrics. He wrote back saying that he'd just walked in the door when my original email request arrived the other day, and that he'd just got the software to convert the track to an MP3. He also said he had a meeting with the music person at APC the next day and that he'd mention it. The next day he said it was OK, and sent me the APC contact email.

I mailed the person, who turned out to be Judith Sraer, the yes/no voice on 'One + Two'. She said it was no problem to use the words, and told me the history of the song. They had originally intended to place the original interview from *One + One* over a backing track, but after trying to contact Godard for permission five or six times with no response, decided to ask a friend, François Robert Lloyd, also an artist on the *Manifeste* CD, to write a new version in the same spirit. She said she had the original sheet of paper the questions were listed on, and could fax that through for me to check my transcription. It contained additional questions that were edited out, which we were able to use in the magazine. Fortunately, I'd taken a few stills from the interview scene in *One + One* which could accompany the text and bring the whole thing full circle.

~~no response, decided to ask a friend, François Robert Lloyd, also an artist on the *Manifeste* CD, to write a new version in the same spirit. She said she had the original sheet of paper the questions were listed on, and could fax that for me to check my transcription. It contained additional questions that were edited out, which were able to use in the magazine. Fortunately I'd taken a few stills from the interview scene in *One + One* which could accompany the text and bring the whole thing full circle.~~

PAUL ELLIMAN

1. HOW WOULD YOU DEFINE A MISTAKE?
2. HOW WOULD YOU DEFINE AN ACCIDENT?

I've got a copy of an old Studio One early teenage Bob Marley and the Wailers' record with the song 'I Made a Mistake' where Bob's singing about losing his girlfriend because of something he did wrong. But in grand Jamaican reggae record production tradition, the labels are printed on the wrong sides. I think Bob's situation was probably due to a mistake and the record label mistake was probably an accident.

3 HOW DO YOU THINK MISTAKES AND/OR ACCIDENTS ADD TO THE CREATIVE PROCESS?

Reggae records are often beautifully misprinted, information is sometimes misspelled, even the centre can be misregistered. All of which gives the music a slightly warped look and sound. I mean a Junior Byles single wouldn't be the same without that ocean-bound drift as it goes round on the turntable. It seems a bit simplistic to be pointing out the similarities between a fresh batch of vinyl and a box of Caribbean fruit: shared means of transport and destination, shared colours and materials, shared economic values, shared symbolism, shared meanings. But the point is that it's unlikely that this kind of cultural resonance could be contrived 'by design', and more interestingly, an aesthetic, however resonant, is a product of so many forces and implications.

4 DO YOU THINK TECHNOLOGY ENCOURAGES OR DISCOURAGES ACCIDENTS?

What I really wanted to get to here is a sort of discrepancy between certain apparently low-cost production values and the technological

content of a reggae record. Because it's also a perfect example of technology being pushed to its limit, and beyond – made to do things it may not have been intended to do, with great skill and awareness but also with irreverence and complete abandon. Jamaican record producers like King Tubby and Lee 'Scratch' Perry always went to extreme lengths in their interactions with technology, which, even if it was never state-of-the-art, was used with an extreme sense of invention. Part of the legacy of this can be seen in hip-hop culture, which began partly as a fusion of reggae sound systems and Kraftwerk-style electrofuturism. In William Gibson's first Cyberpunk novel, *Neuromancer*, an interior space of the computer network unfolds across 'neon forests' and 'towers of data', but it also has a sound: 'the long pulse of Zion dub'. A dread soundtrack that must partly be a reading of Lee Perry's famous Black Ark recording studio. 'I see the studio must be like a living thing, a life itself. The machine must be live and intelligent. Then I put my mind into the machine…' said Lee Perry, the 'dub afronaut'.

7. WHAT DO YOU THINK IS iNTERESTiNG Or aPPeALING aboUT tHE 'UNPREDiCtAblE HOW HAS THE UNPREDiCTABLE ADDED To YOUR WORK? 8 WHAt ROLE DO you tHiNk CHANCE HAS botH iN THE GeNeRAL PROCesS. ANd iN YOur own crEaTiVe pROCEsS? 9 Do YOU THiNk WE cAN DO ANYTHiNG TO EnCOuRAGe CHANCE?

I'm talking about reggae as a way of describing aspects of my work that are grounded in the rougher edges of new technology. Chance is something that plays a part in this work by definition, rather than by special focus. I can't really talk about the psychology of chance or of the accident, or their relationship to technology. And I'm sure a few extra seminars with Freud or Heidegger will only make things worse. But I can feel my own way through material and social

encounters of chance, accidents and technology, and maybe that's a better way of looking at these things in my work. The chance encounter of an umbrella and a sewing machine and, well, anyone. The human-error-prone machine and the machine-error-prone human. Lee 'Scratch' Perry, Buster Keaton, Samuel Beckett. But it doesn't have to be mystical or slapstick or doom-laden; after all we're talking about the most ordinary of human conditions here. Projects of mine – the Bits typeface, the grrrrr.list, or when I'm using system fonts – develop from an interest in ideas about network writing, but they respond to digital culture from very physical perspectives of writing. In the end, like life, they become defined by principles of chance, but it probably wouldn't work like that if I was trying too hard. It would be like trying to be funny or sexy, wouldn't it? It's there or it isn't, and I have trouble appreciating the chanceness or the accidental if you've had to set too many traps for it.

10. Do YOU tHiNk tHeRe's A rELAtiONSHiP BetWeEN ACciDEnts ANd CHANCE? CAn YoU GiVE AN exAMPlE FrOM YOUr OWN WORK? FrOM soMEoNE ELSe'S WORK? 5. JoHn CAGE WAS tHE 'PiOnEEr Of crEATiNG sYsTEMS tHAt 'ENcouRaGE tHE oUTCoMe Of wHiCH caNNOt BE FöRSeeN'. HAVe YÖU UsED sYstEMS iN YÖUr WORk? iF SO, WHAT WERE tHEy AND HoW Did YOu usE tHeM?

I've always liked that Cage quote about using four record players to compose and perform 'a quartet for explosive motor, wind, heartbeat, and landslide.' Lee 'Scratch' Perry once introduced a new song as 'lightning and thunder, hailstone, fire, hurricane and tidal wave, mixed by earthquake, produced by flood.' A few years ago I had a chance encounter with John Cage. We were the only passengers on a number 38 bus on New Oxford Street and we got off at the same stop.

He asked me for some directions. In fact I only realized it was Cage as he was walking away. Later I read that he was here for the premiere of what turned out to be one of his last works, *Europeras 3 & 4*. I went to say hello to him after the performance and he remembered me as 'the boy on the bus'.

I know everyone has some kind of 'John Cage story' and it's usually wheeled out as a kind of parable, but here was just an old American bloke on a London bus, lost. Although I was impressed by aspects of *Europeras*, it was of course highly contrived, very theatrical. Whereas about the same time I'd also been to see the Jah Shaka Soundsystem – one turntable and a klaxon (and sometimes a couple of Lee Perry's barking dogs thrown in). In fact Jah Shaka is a one-man explosion of motor, wind, heartbeat and landslide. I was almost certainly stoned at the time, but I think if I had sat down to compare the two shows I would have felt that Jah Shaka was scouting the outer perimeters of the 'controlled' or the 'organized' in ways that appealed more to me living in London at that time, the late 1980s.

6. IN KEEPING WITH THE IDEA OF CREATING SYSTEMS, DO YOU THINK IT IS POSSIBLE TO 'GET OUT OF YOUR OWN WAY? IF SO, HOW?

No I don't think so. I'm tempted to say that it sounds like part of a myth of objectivity. But I know what you mean. When I started this, I didn't intend to be arguing for roots reggae verses a Cagian modernism, but Kodwo Eshun, who wrote a whole book about 'breakbeat science' and covered lots of things that I've mentioned here, talks about how 'the idea of losing control makes listening to records more fascinating … Basically you want to go AWOL from yourself. But you can't, so you stay and enjoy it.' I feel like this about lots of things in life, especially work.

/ / /

April Greiman

1. How would you define a mistake?
2. How would you define an accident?

A mistake is a mistake. An accident conjures up the chance principle in which all things, situations, ideas, are present simultaneously and just 'happen' to juxtapose in an unusual or different way than you would have expected.

4 Do you think technology encourages or discourages accidents?

Technology definitely encourages accidents.

5. John Cage was the "pioneer" of creating systems that "encourage the outcome of which cannot be foreseen." Have you used systems in your work? If so, what were they and how did you use them?

Sorry, no system approach other than intuition/chance (the highest order of intelligence, as per Greiman!).

6. In keeping with the idea of creating systems, do you think its possible to "get out of your own way"? If so, how?

Rent 'higher-end' technology, use new software that you aren't familiar or comfortable with, and have a go at it, with no 'end' in mind.

7. What do you think is interesting, or appealing about the "unpredictable"? How has the unpredictable added to your work?

You learn something new because you see something new … and, by the way, I am not fixated on making something new. I just love the journey of learning and exploring.

9. Do you think we can do anything to encourage chance?

Same answer as number six.

Stefan Sagmeister

1. How would you define a mistake?

An unplanned outcome, seen at first negatively.

2. How would you define an accident?

A sudden unplanned outcome.

3. How do you think mistakes and/or accidents add to the creative process? In what way have they added to your own work?

I never used to work with my mistakes. I always meticulously planned a project out, drew tight sketches and layouts, and then worked as long and hard as it took to achieve the final version of those sketches. Of course, there are always some accidents in all the handwritten designs we've been churning out, but those have always been tightly controlled too. So my answers here are from a beginner-mistake-maker's point of view. No profound insights, sorry.

We only recently started to involve the process/mistakes and accidents, prompted in part by a Robert Rauschenberg interview in the *New York Times*. In it he states that he tries never to come into the studio with an idea. If he has an idea before starting, he goes for a walk just to get rid of that idea. He says if he does start with an idea, chances are he'll only come up with stuff that he or somebody else has done before him. He wants all the insecurities and doubts of the working process to become part of the final piece.

I started trying this and discovered that the results are radically different, which I enjoyed because I was tired of the stuff I'd been doing. The Type series I sent is one of those results.

4. Do you think technology encourages discourages accidents?

I would think it encourages it. The more complicated the tools, the bigger the possibility for total fuck-ups.

5. John Cage was the "pioneer" of creating systems that "encourage the outcOmE Of which cannOt bE fOrEsEEn." HavE yOu usEd systEms in yOur wOrk? Inf sO, What WErE thEY & hOW DiD YOu usE tHEm?

I work with Brian Eno's 'Oblique Strategy' cards every once in a while (mixed results) and I've been doing time-based restrictions, for example: design a CD cover in three hours, and I do stop after exactly three hours with excellent results. An enjoyable process. Philosopher Edward de Bono developed a much-used system where you start thinking about an idea from a randomly chosen word from the dictionary.

6. In kEEping witH tHE idEa Of CrEating systEmS, dO YOU tHink itS pOSSiblE tO "gEt OuT Of YOur Own WAY?" If SO, HOW?

No, I'll always be in my 'way'.

7. WhAT dO YOU THink iS inTErESTing, Or AppEAling AbOuT THE "UNPREDiCTAblE"? HOW hAS +h3 UNPR3diCTAblE ADD3d TO yOUR WORk?

The exploration of new avenues.

8. WhAT ROLE DO YOu Think CHAnCE HAS boTh inThE GENERAl CREATiV3 PrOCESS, & IN YOUR Own CREATIVE PROCeSS?

See number three. ~~See number three. See number three.~~

9. DO YOU ThiNK WE CAN DO ANyThING TO ENCOURAGE ChANCE?

Be more open, less rigid. Give chance a chance (all we are saying …).

10. DO YOU ThiNK +hERe'S A RELATIONSHIP BeTWeeN ACCIDeN+S & CHANCe? CAN YOU GIVE AN EXAMPLE FROM YOUR OWN wORK? FROM SOMeone ELSES work?

If I accept the accident I give it a chance. Example: projects comes back 'wrong' from the printer. Often wrong is just that, wrong, but every once in a while wrong is better, if I can see it and the client has not approved 'right' yet.

Stefan Sagmeister

1. How would you define a mistake?

An unplanned outcome, seen at first negatively.

2. How would you define an accident?

A sudden unplanned outcome.

3. How do you think mistakes and/or accidents add to the creative process? In what way have they added to your own work?

I never used to work with my mistakes. I always meticulously planned a project out, drew tight sketches and layouts, and then worked as long and hard as it took to achieve the final version of those sketches. Of course, there are always some accidents in all that handwritten designs we've been churning out, but those have always been tightly controlled too. So my answers here are from a beginner mistake-maker's point of view. No profound insights, sorry.

We only recently started to involve the process/mistakes and accidents, prompted in part by a Robert Rauschenberg interview in *The New York Times*. In it he states that he tries never to come into the studio with an idea. If he has an idea before starting, he goes for a walk just to get rid of that idea. He says if he does start with an idea, chances are he'll only come up with stuff that he or somebody else has done before him. He wants all the insecurities and doubts of the working process to become part of the final piece.

Started trying this and discovered that the results are radically different, which I enjoyed cause I was tired of the stuff I've been doing. The type series I sent is one of those results.

4. Do you think technology encourages discourages accidents?

I would think it encourages it. The more complicated the tools, the bigger the possibility for total fuck ups.

5. John Cage was the "pioneer" of creating systems that "encourage the outcOmE Of which cannOt bE fOrEsEEn." HavE yOu usEd systEms in yOur wOrk? Inf sO. What WErE thEY & hOW DiD YOu usE tHEm?

I am working with Brian Eno's Oblique Strategy cards every once in a while (mixed results) and I've been doing time-based restrictions : Design a CD cover in 3 hours, and do stop exactly after 3 hours with excellent results and an enjoyable process. Philosopher Edward De Bono developed a much used system where you start thinking about an idea from a randomly chosen word from the dictionary.

6. In kEEping witH tHE idEa Of CrEating systEmS, dO YOU tHink itS pOSSiblE tO "gEt OuT Of YOur Own WAY?" If SO, HOW?

All Messed Up would definitely have been All Mixed
Up without the following:

Jo Lightfoot, Cleia Smith and everyone at the
glorious Laurence King; Val Palmer, Tricia Austin,
and everyone on the MA Communication Design
course at Central Saint Martins; John Walters,
Nick Bell, Stuart Bailey, Scott Santoro, Fabrizio
Gilardino, Martin Venezky, Ed Fella, LUST.

A big thank you to everyone who contributed their
time, energy and work to this book.

Special thanks to Sarah aka Scaler for all her blood,
sweat and tears, green tea and of course TS;
Marcella for being the best Marcella any Marcella
could ever hope for; Alistair for his beautiful
photographs and enviable patience; Henuis and
Maman for the genetic cloning. And above all for
Nick – 'just as much and even more …'

Namaste,
Anna

LAURENCE KING

First published in 2004 by
Laurence King Publishing Ltd
71 Great Russell Street, London WC1B 3BP
(t) +44 20 7430 8850 (f) +44 20 7430 8880
(e) enquiries@laurenceking.co.uk
www.laurenceking.co.uk

First published in the United States in 2004 by
Harper Design International
An imprint of HarperCollins*Publishers*
10 East 53rd Street
New York, NY 10022
Fax: (212) 207 7654

HarperCollins books may be purchased for educational,
business, or sales promotional use. For information, please write:
Special Markets Department,
HarperCollins*Publishers* Inc.,
10 East 53rd Street, New York, NY 10022.

Library of Congress Control Number: 2003116317

ISBN 1 85669 390 2

Printed in China
First printing 2004